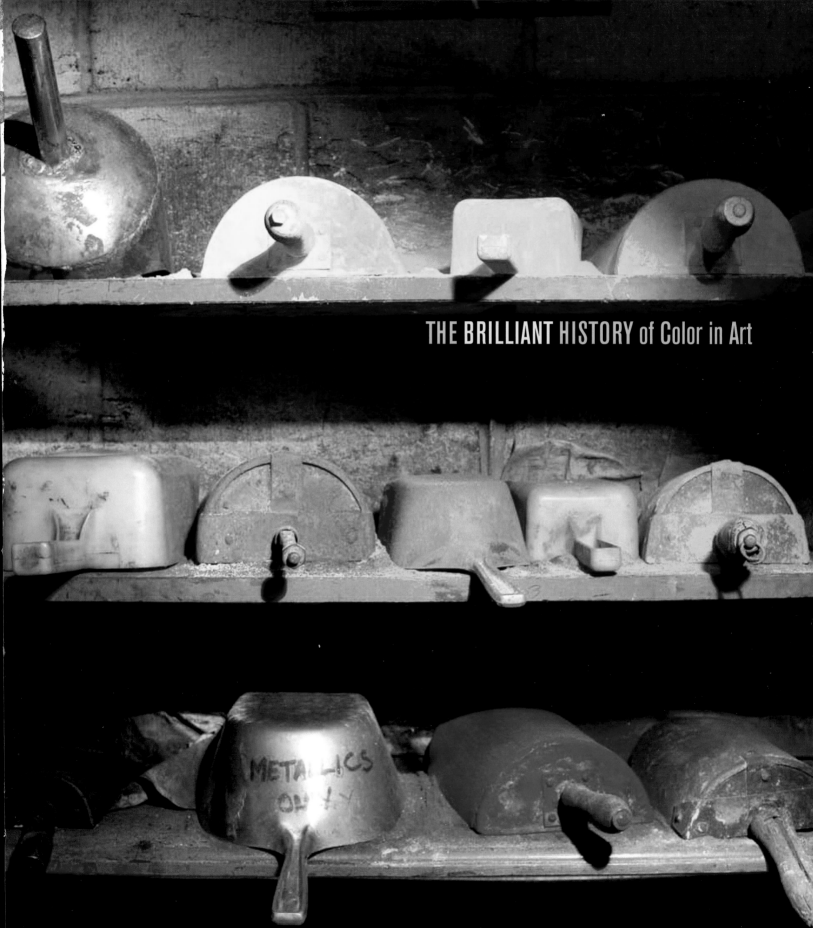

THE **BRILLIANT** HISTORY of Color in Art

VICTORIA FINLAY

THE **BRILLIANT** HISTORY
of Color in Art

The J. Paul Getty Museum
Los Angeles

CONTENTS

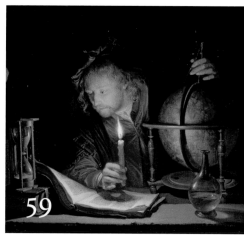

(3) **Modern Colors**

1 Earth and Fire

Manganese BLACK ART IN THE ICE AGE

One Thursday in September 1940, four boys and a dog called Robot went on an expedition. It was the height of the Second World War. The Germans had invaded France that summer and had stopped just a few miles north of the boys' village in southwest France, so these were difficult times. The oldest boy, 18-year-old Marcel Rabidat, had heard stories of ancient tunnels under the nearby woods. He wanted to investigate the entrance to a hole Robot had discovered in

the roots of a fallen tree. The three others were Jacques Marsal, who was 14, Georges Agnel, who was 15, and Simon Coencas, a 13-year-old Jewish refugee from Paris.

Marcel had brought a spade and a couple of lamps. After the boys enlarged the hole, they descended about 40 "terrifying" feet down a long shaft. At the bottom they discovered, rather like Alice did in Wonderland, a surreal underground world where nothing was quite as it seemed.

The boys found they had entered a huge limestone cavern, full of stalactites hanging from the ceiling and stalagmites growing up from the ground. Marcel held one of the paraffin lamps, and as the light flickered against the walls, the boys could see huge animals' eyes staring at them from every side. There were horses and stags, bison, and even a bear. And in the center, on the ceiling

Lascaux Cave paintings, France, Late Stone Age

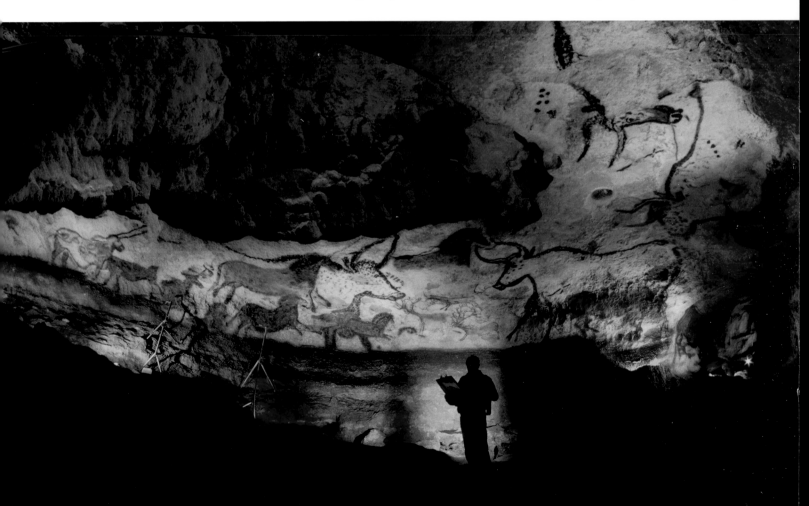

Marcel, Jacques, and Robot, France, about 1940

Cave painting of an extinct steppe bison at Altamira, Spain, Late Stone Age

high above their heads, was a huge bull, 17 feet long. The paintings were so realistic they almost seemed to be breathing. The flanks and backs of the animals were painted in bold red and yellow colors and were outlined with strong black lines. The four boys were the first modern people to see these paintings since they had been created at the end of the Ice Age, about 17,000 years ago. And as it turned out, they were among the very few people ever to see them with their bright colors intact.

Red. Yellow. Black. White. Brown. These were the colors of the first known art in the world. You could say this is what you'd expect; they are, after all, colors found easily in nature. Red and yellow ocher are found naturally where the ground is full of iron. Black can be made by burning a

stick into charcoal or collecting soot from a fire. White comes from chalk. And brown is just the color of dirt. If these materials are pounded into powder and mixed with animal fat or some other binder to make them stick, then, with the right atmospheric conditions, they can stay on limestone walls for thousands of years. But that isn't the full story of the colors of what became known as the Lascaux Caves.

In the 2000s, French scientists took a tiny sample from the snout of the Great Bull. They found that some of the black was not just soot or charcoal but also contained a rare kind of manganese oxide called hausmannite. This can be made artificially by heating rocks that are rich with manganese, but the process requires temperatures of around 1650 degrees Fahrenheit, and it's

Altamira

The earliest discovery of cave art in Europe was near a Spanish village called Altamira. One day in 1879, a landowner named Don Marcelino Sanz de Sautuola went into a cave with his young daughter Maria. He was looking at the ground, examining some Stone Age tools found a few years before, while his daughter played on the floor. Suddenly the little girl squealed in excitement, "Look Papa, bulls!" she said. And there, above them, painted in red, yellow, black, and white, were herds of bison thundering across the ceiling. At first people accused Sanz de Sautuola of forgery because they didn't think prehistoric people could have been so clever. But they were wrong.

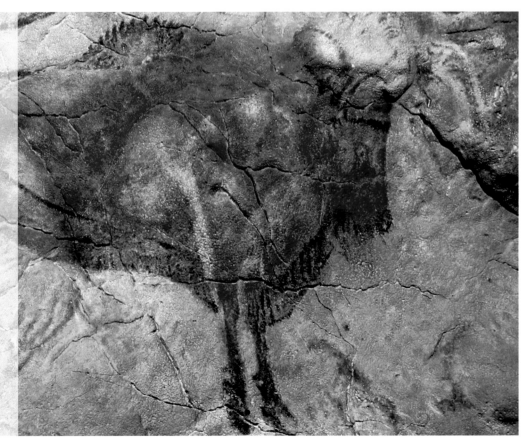

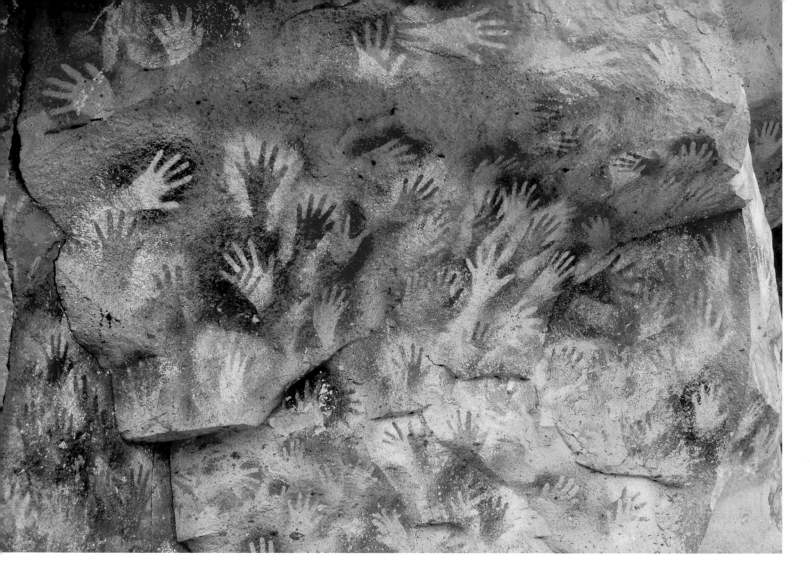

hard to see how prehistoric people could have generated that kind of heat from their open-pit fires. There could have been a local source we don't know about anymore, but it is also possible that the Lascaux hausmannite came from the Pyrenees Mountains, 150 miles away.

Obviously we don't know exactly how the hausmannite got to the Lascaux Caves. Maybe it was brought by traders, or maybe the tribe sent out expeditions of young men to go and get it, or maybe the people who painted these caves came from across the Pyrenees on the way to somewhere else. But the possibility remains that 17,000 years ago, certain kinds of paint had value and were worth carrying a long way.

There are other things to learn from the Lascaux Caves. First, tools would have been needed to create the different effects on the paintings. The paint on the Great Bull was applied by mixing ground minerals with something liquid and then spraying it from the mouth, either straight or with a blowpipe. It probably tasted horrible, but the same idea occurred to a lot of people around the world in prehistoric times. You can see similar techniques in other caves, not just in Europe but also in Australia from 40,000 years ago, as well as in the Kalahari Desert in Africa, in the Patagonian Mountains in Argentina, and in Baja California. In some of those places you can see how artists experimented with different effects, including spraying paint

Cueva de las Manos, Patagonia, about 11,000–7000 BC

In an isolated spot in the Patagonian Mountains, at the southern end of Argentina, you'll find Cueva de las Manos (Cave of the Hands), whose walls feature a striking collection of painted silhouettes of hands. Most are left hands, suggesting that the artists holding their blowpipes were probably right-handed.

Pigments vs. Dyes

The word "pigment" comes from the Latin *pingere*, meaning "to paint," so maybe it should really be "pingment." In art it means the colored powders that can be suspended in a binder such as glue, oil, egg, or acrylic to make paint. Pigments are usually made of minerals, although, as we'll see, they can be made of insects and bones and other stuff as well. The key thing is that pigments don't dissolve in the binder; they stay suspended as they are.

Dyes are thinner, and they dissolve. They are mostly used for coloring fabrics. They usually have to be "fixed" onto the fabric so the color doesn't wash out. The substance that does this is the "mordant," from the Latin word for "biting," because it causes the color to get its teeth into the fibers and hopefully not let go. Mordants include metals, urine, and alum, and sometimes the smoke in a small room has been known to do the job. Pigments cannot be made into dyes, but dyes can be made into paints by fixing them with a mordant onto a white mineral powder, such as clay or crushed bone or salt. Paints made from dye are known as "lakes."

over their hands to create silhouettes. Other paints at Lascaux were applied in more predictable ways—as finger paints or with brushes probably made from deer hair. But some outlines were made from soot mixed with really waxy clay, suggesting that even that long ago people were making and using crayons.

What were these astonishing paintings for? And how did their makers climb up so high inside the huge cave? Were the artists hunters, recounting their adventures? Or priests, asking the gods for good luck? Perhaps the animals were painted by professionals who traveled from cave to cave, like the craftsmen who would later travel from one cathedral to another in the Middle Ages. Or maybe the paintings were made by Ice Age teenagers looking for entertainment through yet another long, boring winter. We will never know.

But we do know there was light in those caves when the animals were painted—they couldn't have been painted in the dark—and there was light when they were viewed by whoever came in to see them. And if you look closely at the animals, you will see that by choosing certain colors and varying their shade, depth, and application, men or women 17,000 years ago created the impression of sunlight dappling onto the backs of living creatures. Like so many artists after them, they used color to breathe life and light into something that previously existed only in their memory or imagination.

The boys' first instinct was to keep the caves a secret, especially with enemy soldiers so near. But within days, visitors started to arrive (with Marcel at the door, charging 40 centimes for a tour). In the beginning everyone slid down on pieces of wood, or, as *Life* magazine's photographer Ralph Morse later described it, "on your rear end on the

bare earth." The world-famous prehistoric art specialist Abbot Henri Breuil happened to be visiting a nearby town and raced over as soon as he heard. And when he went down with his flashlight and magnifying glass, he pronounced that not only were the paintings authentic; they were also possibly the greatest prehistoric art ever seen.

Simon went back to Paris a few days later, and although he was sent to an internment camp he was released because he was under 16, and he managed to stay hidden throughout the war. (In 2014 he is still alive, the longest lived of the group.) Georges also went home soon after, to start his school term. Jacques was arrested in 1942 and sent to a forced labor camp in Germany. Marcel joined the French Resistance, hiding out in caves near the ones he'd helped discover. And after the war ended in 1945 he and Jacques became official guides at Lascaux, telling the story over and over about what it was like to climb through the hole and see the Great Bull for the first time.

By 1948 the owner of the land above the caves had opened up a doorway, and 1,000 people were arriving every day, nearly 400,000 a year. Their breath, and the warm air now flowing into the cold caves, created a kind of dew on the walls. And with that, and new electric lights, the vivid colors began to fade. The paintings that had been preserved in darkness for so many thousands of years became almost invisible within just 20.

And this is another element of the history of colors in art: they are there, and then they go. They do not stay the same, and when you look at a painting, you're also, in a tiny way, changing it.

RED Ocher THE SACRED AND DANGEROUS IN AUSTRALIA

The Tiwi Islands off the northern tip of Australia have an Aboriginal population of just a few thousand. For a long time, that was the number of people the Tiwi Islanders thought existed in the entire world. In their language, *tiwi* means "we, the only people."

Over the years the Tiwi Islanders established a way of making sure that people don't marry those who are too closely related. They use colors. When Tiwi children are young, they are told which color they "are." Some children are red, representing the sun; others are black, representing stone; others are white, for the pandanus bush; and the rest are yellow, for the mullet fish. Reds have to marry yellows or whites; they cannot marry anyone who's red or black.

The islanders use the four colors for many things. One is to create amazing painted funeral poles called *pukumani*, meaning "taboo" or "dangerous." In the past, outsiders were normally not allowed to see the poles at grave sites. But when the first Tiwi tour guide died in the 1990s, his family decided to allow visitors to see the poles created for his funeral, with his life story painted in special code. The man was a red, so the poles were mostly red ocher, with dots and lines representing the important people and places in his life. One pole had large yellow oval shapes painted around the top. "What are those?" asked one visitor in a hushed voice. "Oh, those are Aussie Rules footballs. He loved playing footie."

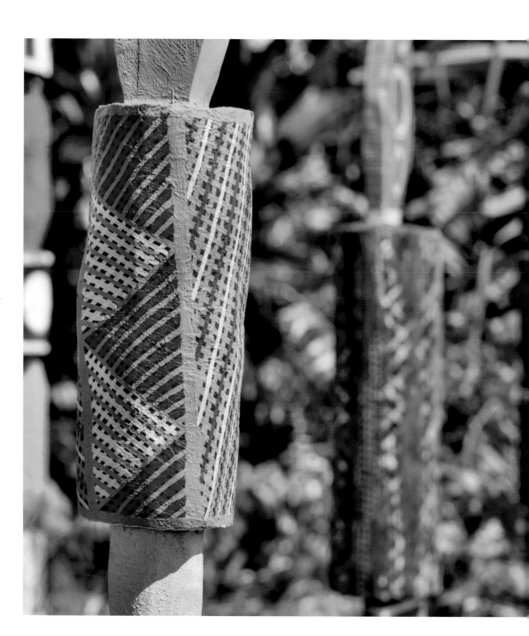

Pukumani **pole, Australia, 2011**

Dry streambed with ocher, making a natural paint box, at Jumped Up Creek, Beswick, Australia, 2000

The Tiwi colors all came from the islands, but on the mainland Aboriginal people sometimes had to go far away to get the best paints. Ordinary red ocher can be found in many places in Australia. If you look down from an airplane the whole continent seems to be red, and virtually every streambed has stones that can be ground into powder for paint. But sources of sacred red ocher were rare and worth traveling for.

One place for sacred ocher was Wilga Mia, in the Campbell Range of Western Australia, and another was the Bookartoo mine at Parachilna in South Australia. Until the 1880s at least, there are records of 70 or 80 young men from the Diyari tribe near Lake Howitt heading south to Parachilna every year on a pilgrimage to collect the red paint. It would take two months to do the 1,000-mile round trip. They'd trade boomerangs, axes, and a bush tobacco called pituri, and once they returned home with their possum-skin bags full of ocher, the men of the tribe would use it to decorate their bodies for sacred rituals.

This red was believed to be so dangerous it could be seen only by certain men, and never by women. On some occasions, people who saw it when they weren't supposed to were killed. The reason why that particular color was so special is still a tribal secret. It could be because red symbolizes blood and death, but some anthropologists suggest that this particular paint is considered dangerous because it shines. Until Europeans arrived in the 17th and 18th centuries, Aboriginal people in Australia had no access to metal or glass. And just about the only shimmering things were sweat and blood, or water in a pool after rain, or mirages in the hot desert. In such a culture, the brilliance of the red paint might have been believed to have a special power, perhaps to open a window into the world of the Ancestors.

The Australian Aboriginal people, whose painting tradition goes back about 40,000 years, were not the first to use this paint. In Africa, people were using red ocher

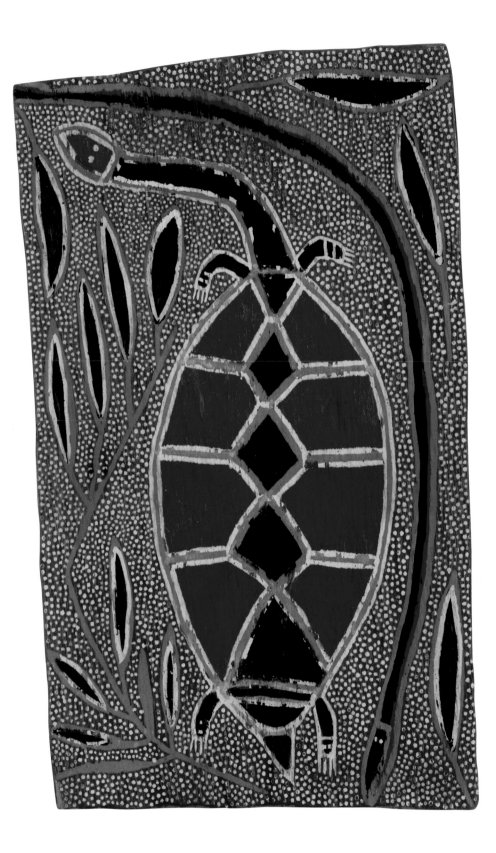

thousands of years before that, and long before people in Europe ever picked up their deer-hair brushes. In 2008, archaeologists in the Blombos Cave in South Africa's Southern Cape unearthed the earliest painting kit ever discovered. It includes abalone shells used as palette bowls, with red and yellow ocher residues, as well as stone tools used to grind the pigment and bone spatulas that might have stirred the paint pastes. And there were two brick-like blocks of red ocher that had been incised with diamond-shaped marks, which could be the earliest examples of artwork in the world even though—curiously—ocher was used not as the paint but as the artwork itself.

The whole kit had been hidden under sand 80,000 years ago. "All these artifacts were found together," said a BBC reporter in 2011, "almost as if someone had put them down intending to retrieve them at a later time." But no one ever did.

Fresh Water Turtle and File Snake by Tony Djikululu, about 1965
The use of natural pigments, such as ocher, remains important in some Aboriginal painting traditions.

Red Ocher and Dying Stars

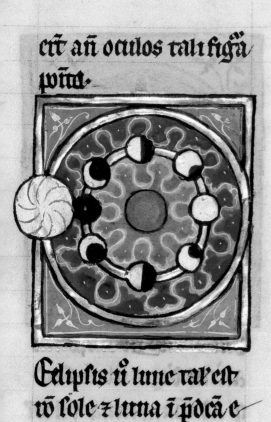

cit añ oculos tali figra wntu·

Eclipsis tī lune rat est tō sole Ꝫ lntna ī pōcā e

Diagram with the Sun and phases of the Moon from *On the Nature of Birds*, France or Flanders, about 1275–1300

The most common red pigment on Earth is red ocher, also known as iron earth. Barns in Scandinavia are painted with it; roads are sometimes surfaced with it; red bricks get their color from their iron content. But why is iron earth so plentiful that it's one of the cheapest colors? The answer can be found in the stars, and in nuclear fusion. So hold on tight: this is a pretty atomic explanation.

Hydrogen is the lightest element, usually with one proton and no neutrons (atomic weight: 1). And this is how a star begins its life—as a massive sphere of hydrogen. Then the pressure of gravity at the center of the star starts to push the hydrogen atoms together. They begin to crash into each other with such force that they fuse and become helium (which is the next-lightest element, with an atomic weight of 4). This is nuclear fusion and is what's happening in the Sun, which is a relatively young star.

After several billion years, the hydrogen starts to run out. All that fusion energy fades a bit, and the star starts to cool and shrink. But that's not the end of the story. The tremendous pressure of this cooling and shrinking compresses all the matter inside the star, and the smaller atoms fuse into larger, heavier ones. The compression now makes the temperature rise until it's hot enough for another nuclear reaction, this time with the helium. But it's a slightly smaller reaction

because the helium doesn't fuse so easily. The next time the power levels fade the same thing happens, but this time the elements get even heavier. And so it goes on. The crunch point is an atomic weight of 56.

At this point the star collapses and explodes as a supernova, full of a lot of elements but with plenty of the heavy matter whose creation has caused the final explosion. This still isn't the end of the process. Collapses are pretty dramatic events, and the pressure is raised once again, setting off another heap of nuclear reactions producing all the heavier elements we are so familiar with—including copper, arsenic, gold, silver, and zinc—and scattering them across the universe to combine with each other and sometimes (thanks to gravity) even make planets. But these reactions don't produce any more nuclear fusion energy; they just produce stuff.

The element with an atomic weight of 56, the one produced when a star goes supernova, is—you've guessed it—iron. It is the fourth-most-common element in the Earth's crust. (Third is aluminum, and second is silicon.) And the most common element on Earth is oxygen. Red ocher contains iron and oxygen, in the form of iron oxide, Fe_2O_3. So perhaps it's not surprising that this particular red is the most common pigment, not only on Earth but in the universe.

Egyptian BLUE KING TUT'S INFRARED TRANSMITTER

The first European book to mention pigments in any detail was written in Athens in the fourth century BC by the philosopher Theophrastos. It is a short book written in a casual style, so some people think it could be just a set of notes jotted down by one of his students during a lecture. Imagine if your own class notes were all that remained to tell people in the future about what we think of a particular subject today. That may be what happened with *Peri Lithon*, which can be translated as *About Stones*. It's our earliest guide to what ancient Greeks (or at least Theophrastos) knew about rocks

Glass eye made for a statue, Egypt, about 1540–1070 BC

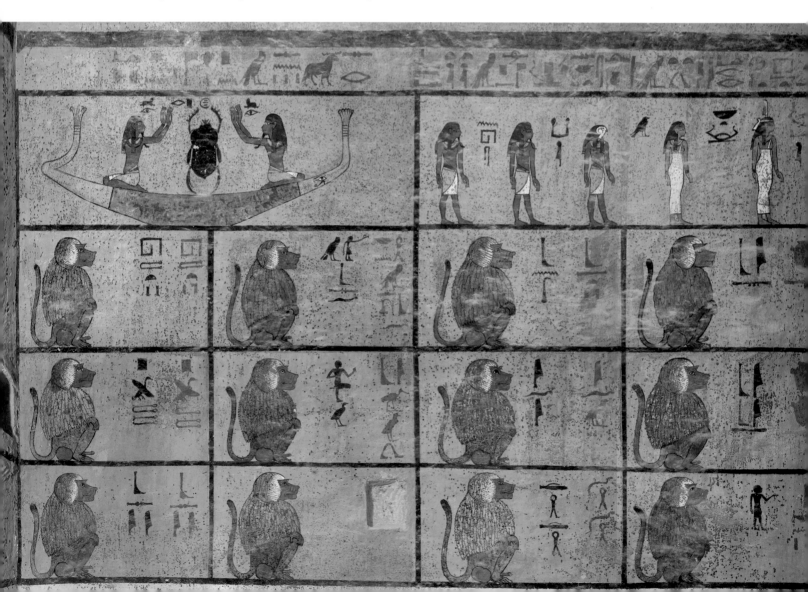

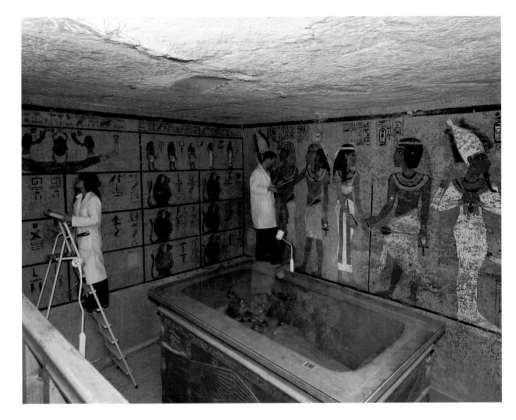

Left: Baboons painted on the walls of Tutankhamun's tomb, Egypt, about 1300 BC

On February 16, 1923, the British explorer Howard Carter broke through a sealed door into the tomb of the Egyptian boy-king Tutankhamun, who had been made pharaoh at age nine and died 10 years later. The painting on the west wall of the inner chamber showed 12 baboons, painted in Egyptian blue, each representing one of the hours it was believed Tutankhamun would spend in his night journey to the underworld.

"The temptation to stop and peer inside at every moment was irresistible, and when, after about ten minutes' work, I had made a hole large enough to enable me to do so, I inserted an electric torch. An astonishing sight its light revealed, for there, within a yard of the doorway, stretching as far as one could see and blocking the entrance to the chamber, stood what to all appearances was a solid wall of gold."

Above: Conservators from the Getty Conservation Institute examining the wall paintings in the tomb of Tutankhamun

and metals, including what happened when you set them on fire or smashed them into pieces—and whether they were any good as pigments for paint.

There were plenty of paint colors available in Athens 2,500 years ago. In addition to the reds, browns, blacks, and chalks we saw in the Lascaux Caves, there were metallic reds found in silver and gold mines, dangerous yellows made of arsenic, bright greens from copper suspended above casks of sour wine, and the brightest of whites from corroded lead (we'll be meeting all of those later).

And there was blue. In fact, there were three kinds of blue available in ancient Greece. But the finest of them was from Egypt. Theophrastos was really impressed by this blue, which he knew was so precious that the Phoenicians—who were without doubt the best traders in the world at the time—used to give it to their business partners as a

kind of thank-you. He knew that rather than being found in the ground, this blue had to be made by a chemical process. And he also knew the technique was very old.

Today it's easy to bunch together ancient Rome, ancient Greece, and ancient Egypt as all being rather, well, ancient. But for Theophrastos, ancient Egypt was almost as long ago, and just about as hard to imagine, as classical Greece is for us today. Egyptian blue was invented in about 2200 BC, when the Great Pyramids were built, so around 1,900 years before Theophrastos was writing about it in Athens.

This blue was made in a similar way to glass, so the materials were relatively easy to obtain. It required only lime (calcinated limestone) and sand, as well as a mineral that contained copper (the gemstone malachite, the blue stone azurite, or even bronze filings). The challenge was that the quantities had to be carefully measured and the furnace had to be heated to between 1470 and 1650 degrees Fahrenheit. If it was too hot, the mixture turned into a kind of glassy, green mess; if it was too cold, it turned into another kind of glassy, green mess. But if they got it just right, the ancient Egyptians would get an opaque, blue, crystalline material. And artists would grind it into a powder and mix it with egg white, glue, or acacia gum to make a beautiful paint, the color of swimming pools in summer. "It is the oldest synthetic pigment," commented color historian Philip Ball, "a Bronze Age blue."

Egyptian blue was used until Roman times, and then it was forgotten. Perhaps that's not surprising: it was so complicated to make that, when the method was lost, it was nearly impossible to reinvent. By the time scientists worked out how to make it again in the 19th century there were other excellent blues available, so Egyptian blue

was just a curiosity—until, that is, a scientist made an accidental discovery.

One September morning in 2006, conservation scientist Giovanni Verri was in the X-ray laboratory at the Getty Villa in Malibu, California, examining a 2,500-year-old Greek marble basin. It showed paintings of Achilles's glamorous mother and aunts, the Nereids, bringing him pieces of armor before he went into battle. Verri was using infrared photography to see whether the artist had sketched out the design in black before painting over it. (Carbon black absorbs infrared rays, so sometimes underdrawing can be picked out with infrared light.)

"My infrared tungsten radiation source wasn't working, so I had to use the fluorescent tubes on the ceiling," Verri remembers. "Those are never used for infrared imaging, as they emit very little infrared." When he looked at the image of the basin, most of it was dark gray, as he would have expected. But when he looked at the sea creatures, he gasped. "They were covered in glowing light," he recalls. And when he looked closer, he realized the glow came from the blue paint.

Verri called his colleagues over. They gasped, too. The images demonstrated that Egyptian blue has the almost unique property of emitting infrared radiation. This means that whenever you shine green or red light on it, the blue pigment absorbs it and then reemits it as infrared radiation, rather like the remote control on a television.

"Using this natural property of the pigment, you can see where Egyptian blue was used in any painting," Verri says. Even when there's only the tiniest amount of this blue on an object, even when it's been under the sea for years and is covered by encrustation, if you point a camera with an infrared filter over the lens at it, the traces of ancient blue will glow unmistakably. And this extraordinary property can be used to find out what the art of the classical world once looked like. It's often the only way to do that, as all that's left of the pigment on marble sculpture, for example, is mostly now invisible to the naked eye.

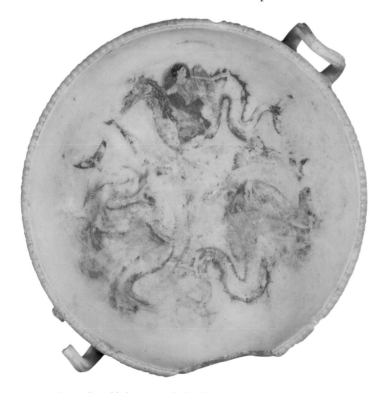

Painted marble basin, Greek, late fourth century BC

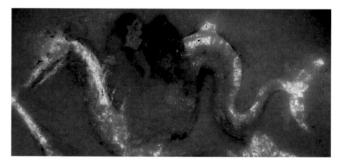

Infrared image of the same basin, with the Egyptian blue paint appearing to glow

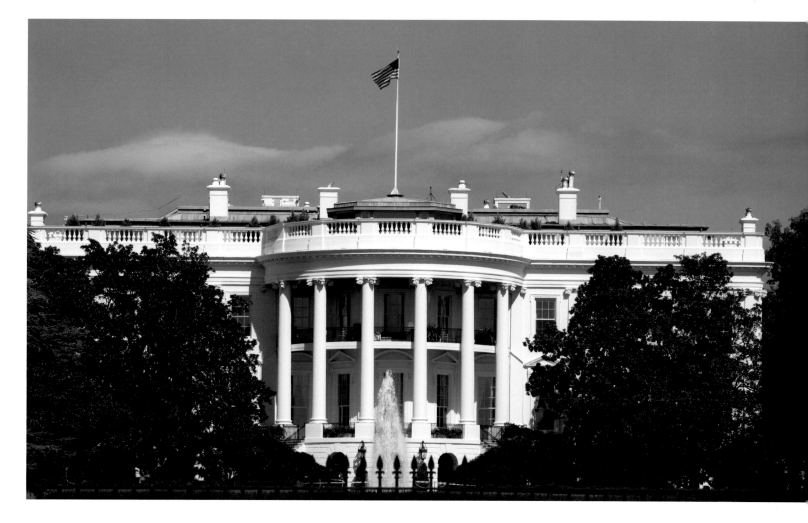

Greek WHITE

THE MYTH OF THE WHITE CITY

When the founders of the newly formed United States of America sat down with the French American architect Pierre Charles L'Enfant in 1791 to plan a new capital, they decided they wanted it to look like a classical city. They were modeling their country as a democracy, which was a Greek idea, and some of their politicians were going to be "senators," which was a Roman idea. So they determined that the city would be laid out in a grid, like Greek and Roman towns,

and that the Capitol building, where the laws would be made, and the president's house, where the chief executive would live and work, would have columns and capitals and pedestals and marble statues, just like the Acropolis in Athens and the Pantheon in Rome. And, of course, like those ancient structures, they would be entirely white. Except that most of the important buildings and sculptures of ancient Greece and Rome were not white. We now know that

The White House, designed by James Hoban, 1792–1800

When the White House was decorated in 1800, it took 2 tons of lead white to paint the woodwork inside, and 100 tons of lime white to paint the stonework outside. Today the U.S. president's house is touched up every year, with 570 gallons of bright white paint.

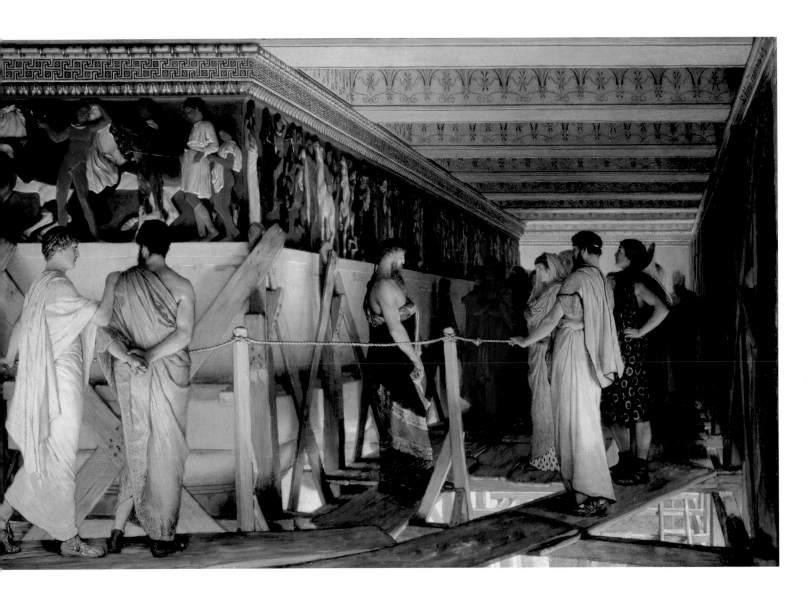

just about all of them were once covered in bright designs; some were even decorated in pure gold leaf. But that didn't fit with what people in later centuries wanted to see. They thought colors were frivolous and showy, and they preferred to imagine an idealized, pristine white classical world.

So when ancient marble treasures were dug up in Greece and Italy from the 15th century onward, dealers would scrape the pieces down with scalpels (or, worse, wash them in an acid bath) to get rid of any paint and reveal the clean, white marble underneath. And when wealthy patrons, in the Renaissance and afterward, commissioned new sculptures in what they considered "classical" style, they wanted no paint at all. "Sculptors . . . need not concern themselves with color," announced the great Italian artist Leonardo da Vinci in the late 15th century. And that, for a while, was that.

But then in the 19th century the science of archaeology was invented. And the archaeologists were really strict about what you do

Pheidias and the Frieze of the Parthenon by Sir Lawrence Alma-Tadema, 1868–69
In 1868 the English Dutch artist Sir Lawrence Alma-Tadema imagined what it must have been like when the marble carvings at the top of the Parthenon Temple in Athens were first unveiled 2,500 years earlier. Alma-Tadema's choice of colors was deliberately provocative: in his day, the Parthenon carvings were held to be shining examples of classical white sculpture.

Right: Statuette of Apollo, Greek god of music, about 300 BC

with the things you find in the ground—how you conserve them and how you record everything in minute detail. And once they started having rules—not scraping paint off or dipping things in acid, for example—they began to find more and more traces of colored pigments (which they called "polychromy," from the Greek words for "lots of colors"). They had to hurry, though: like the paintings at the caves in Lascaux, as soon as those few remaining colors hit the air and light after centuries in the ground, they started to disappear.

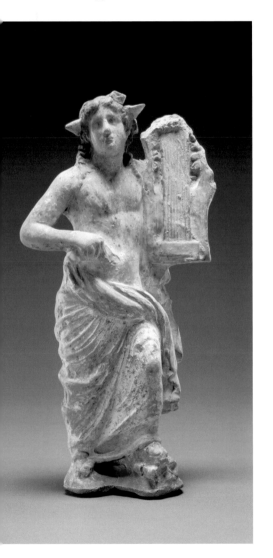

This new evidence of color in the classical world captured the popular imagination. In the 1880s, visitors flocked to exhibitions that displayed plaster casts of ancient statues, painted in what were believed to be their original colors. Still, some people were not convinced. "I feel *here* that they were never colored," pronounced the French sculptor Auguste Rodin, thumping his fist against his chest.

Many experts stuck with the idea that ancient sculptures were only partially painted. They noticed how the hands and faces of Greek statues were usually highly polished, and traces of red and yellow pigments (which are the ones that are most visible after 2,000 years) were mostly found on clothing and hair. So until recently it was believed that the flesh areas of marble statues might have been left unpainted, while clothing and hair were colored.

But since the imaging technique for identifying Egyptian blue was invented in 2006, conservation scientists have been able to test for this ancient blue pigment with just a camera and an infrared filter. And they have been amazed to find the color everywhere. They've found traces of blue on swords, on saddlecloths, and in the whites of eyes. They've found it on the backs of sculptures, where nobody would ever look. And, the scientists were intrigued to discover, it was also on many of the statues' skin-toned areas, such as faces and hands.

So a new explanation for the skin being highly polished is that polishing was preparation for painting rather than an alternative to it. Artists might have buffed up the stone surface and then layered a blend of red, white, yellow, black, and blue paint on

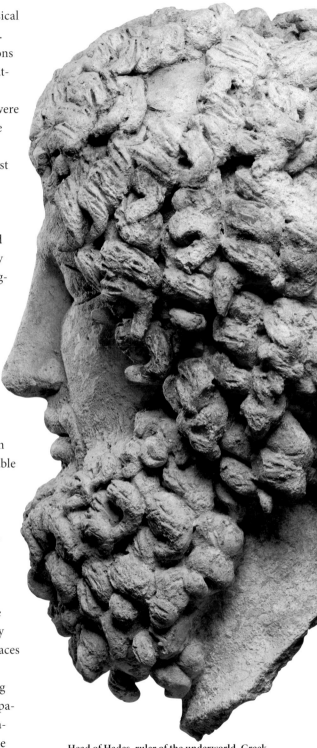

Head of Hades, ruler of the underworld, Greek Sicily, about 400–300 BC

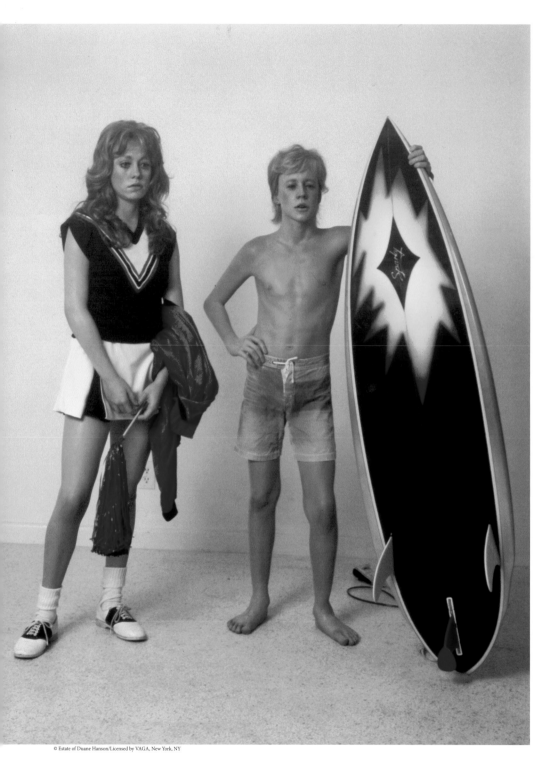

top until they reached a realistic skin color. "Then when light shone on the sculpture, the polished marble would create a kind of translucence that would bounce through the painted area and scatter the light," suggests Getty antiquities curator Kenneth Lapatin. "It would give it a sense of life, and of a light from inside."

These discoveries don't mean that all sculptures were fully painted, but they do open up our understanding of the ancient world. We can imagine that some sculptures would have been fully painted and made to look like real people, while others would not have been. And after more than 2,000 years, it's only now that we are starting to understand the ancient world according to its colors.

The Cheerleader and *The Surfer* by Duane Hanson, 1988 and 1987

When American artist Duane Hanson started painting his life-size casts of models in the 1960s, he found out that the process was different from painting on canvas. He had to exaggerate the light and shade, particularly around features such as the eyes. He experimented with different media, including crayons, to suggest imperfections in the skin, and he used nail polish over oil paint on the fingernails. By contrast, in the 18th century, when Joseph Nollekens carved the Venus on the opposite page from marble, he didn't feel he needed any color at all. Which do you like better?

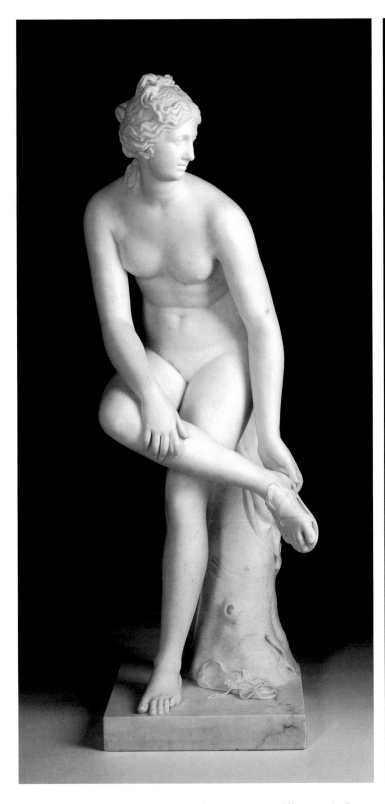
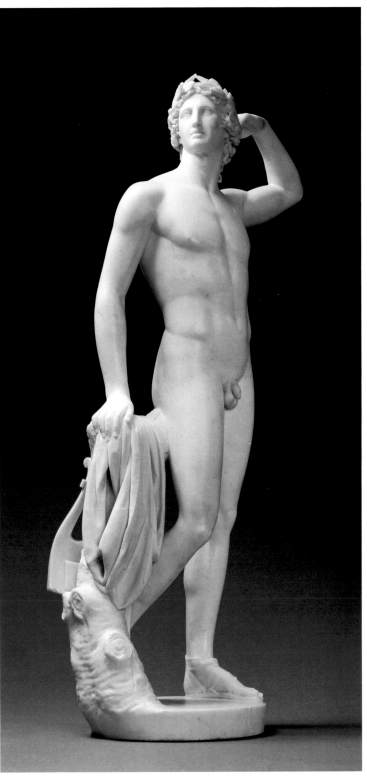

Venus by Joseph Nollekens, 1773, and *Apollo Crowning Himself* by Antonio Canova, 1781–82

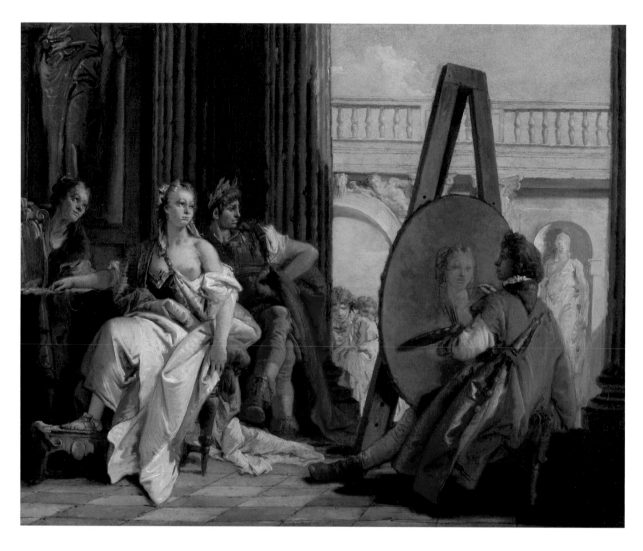

Alexander the Great and Campaspe in the Studio of Apelles by Giovanni Battista Tiepolo, about 1740

A story goes that Alexander the Great commissioned Apelles to paint a portrait of his favorite concubine, Campaspe. But as Apelles painted the beautiful young woman (using just the four colors—red, white, black, and yellow), he fell in love. Far from being angry, Alexander showed his admiration for Apelles by giving Campaspe to him as payment for his work.

Yellow OCHER APELLES AND SLIME

Apelles was the favorite painter of Alexander the Great, and he was a celebrity. A single one of his pictures would sell for the price of an entire city—which puts the millions of dollars spent today at art auctions in perspective. (The most money ever known to be paid for an artwork is $250 million, for Paul Cézanne's *The Card Players* in 2011.) Yet the curious thing about Apelles was that,

although there were so many bright colors available, he is said to have used only four, probably the same four that the Lascaux painters used and that the Tiwi Islanders in Australia worked with to organize their world: red, white, black, and yellow.

The red was an earth from the city of Sinope, in what is now Turkey. The white was imported from the Greek island of

Melos. The artist invented a black made from burnt ivory from Africa (called *ele-phantinon* by the Greeks, for obvious reasons). And the yellow was an ocher from Athens called "Attic sil" ("properly speaking, a kind of slime," the first-century AD Roman historian Pliny the Elder described it).

The word "ocher" originally comes from the Greek for "pale yellow" (even though its meaning has shifted to mean almost any earthy pigment). It's an iron-rich earth colored either by hydrated hematite, $Fe_2O_3H_2O$, or by an iron mineral, goethite, named after the German poet Johann Wolfgang von Goethe (who was fascinated by minerals and a lot of other things). It is found in many places around the world, although some of the most important are in the Luberon in southern France, where the hills shine with oranges and yellows. Even the best of it is a humble paint, although with it, Apelles apparently conjured up almost all the colors in the world.

About Yellow

• Yellow is the most visible color. Using it as a computer background can give you eyestrain.

• Yellow was the color of the emperor in China. Only he could wear it.

• Insect blood is usually pale yellow. If you squash a mosquito, the red blood is probably your own.

• When Oscar Wilde was said to be reading a "yellow-bound" French novel, it was shorthand for saying the stories were rather naughty.

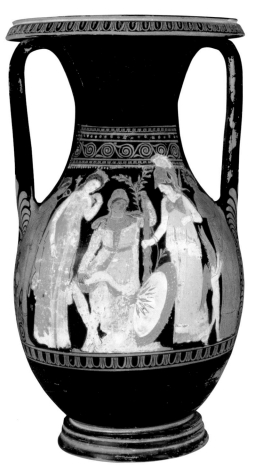

Attic red-figure *pelike*, Greece, about 360 BC
Red-figure pots are familiar artifacts from ancient Greece. Some of the finest, such as this one, had bright colors painted on them after the pot was fired. This *pelike* was made in Athens but was found in the seaside colony of Kerch on the Black Sea, so it was probably made for export. It shows Hera (in red), Athena (in malachite green), and Aphrodite visiting the handsome Prince Paris of Troy so he could decide which goddess was most beautiful. Not surprisingly, his decision led to all sorts of trouble.

Apelles loved to mock. One of his students showed him a not-so-good sculpture of Helen covered with gold paint. "Young man," he told the student, "incapable of making her beautiful, you have made her rich."

Apelles was said to have had a kind of effortless grace that made his art special. When he was a young man, he visited Greece's leading artist, Protogenes, on the island of Rhodes. When Apelles arrived, Protogenes was not at home, and an old lady asked him to leave his name. Instead, he picked up a brush that was lying in the studio, and, going over to a prepared wooden panel, he painted a line in a single, extremely thin brushstroke.

When Protogenes got home he knew his visitor must have been Apelles, because nobody else could have painted that perfect line. He took a different color and painted an even thinner one beside the first, and told the old lady to show it to Apelles when he came back. Apelles knew he had been outdone, but he painted a new line between the two in a third color, and when Protogenes saw it, he admitted he was beaten.

Four hundred years later, the panel had become one of the great treasures of the Roman Empire, displayed on the Capitoline Hill in Rome. "Upon its vast surface it contained nothing at all except the three lines, so remarkably fine as to almost be invisible," wrote Pliny, who had seen it in his youth, before it was destroyed in a fire. "Among the most elaborate works of numerous other artists it had all the appearance of a blank space; and yet by that very fact it attracted the notice of everyone, and was held in higher estimation than any other painting there." It was the first minimalist painting recorded in art history, executed with the simplest brushstrokes and colors possible. And this painting began a debate that would carry through art history. What, after all, was art all about? Were lines more important, or colors? And what was it to be a great artist?

How Do You Know the Ingredients in a Work of Art?

This book is filled with stories about the stuff that gives art its colors: the black mineral in an ancient cave painting, the precious gem ground into blue for a medieval manuscript, the automobile paint on a modern sculpture. But how do we actually know what's in there?

Scientific testing can help. Conservators remove tiny samples for analysis when they can, but some works of art are so small or so delicate—such as the paintings in illuminated manuscripts—that unless fragments fall off on their own, conservators won't remove even the smallest bits. Fortunately, there are scientific techniques that don't require taking samples. Most of them use various forms of light—infrared, ultraviolet, and X-rays—to identify the colors without harming the art.

X-rays can be used to identify the chemical elements present on a painting. A narrow beam of X-rays is directed at an area to be studied, and the X-rays that come out are changed by the elements they have interacted with. This technique is called X-ray fluorescence, or XRF. It can determine, for example, if a white pigment is lead white (available since ancient times), zinc white (available since the late 18th century), or titanium white (available since the early 20th century). Knowing which white was used can be very important for determining when a painting was made.

Another technique, called Raman (no, not the noodles, that's ramen) spectroscopy, uses laser light to identify pigments. As in XRF, a laser beam is focused on a small section of the painting, but in this case the light that is scattered back contains information not only about what elements are present but also about how those elements are combined to form specific chemical compounds.

A scientist uses a Raman spectrometer to examine the pigments in the early-17th-century manuscript *General History of Peru* by Martín de Murúa

X-ray fluorescence spectroscopy being used to analyze the pigments in *The Angel Taking Leave of Tobit and His Family* by Jan Victors, 1649

Raman spectroscopy can be used through a microscope, where, for example, it can distinguish a single particle of ultramarine from a single particle of azurite, even if they are mixed together in the paint.

You can't usually identify the organic materials in a painting—such as the oils, gums, or eggs used to bind the pigment particles together—without taking a small sample. Sometimes a sample can be analyzed using Fourier-transform infrared spectroscopy. This technique uses infrared light to measure how each molecule in the paint is vibrating, and then it compares the vibrational patterns to those in a database, much the same way that police detectives match fingerprints. Another method commonly used is gas chromatography-mass spectrometry, which involves vaporizing a sample and injecting it into an instrument that separates it into its component parts.

No one method can give all the answers. So, knowing what substances were in use at what time and in what place, conservators make educated guesses based on studies of similar works; or on historical evidence, like artists' letters or journals; or on whether the paint seems to have reacted in predictable ways to the passage of time and changes in conditions.

All to say that in this book, sometimes you will see a work of art in a particular section because we know it contains that particular substance. But sometimes a work is here because experts believe that it contains a certain color, but they can't say so with 100% certainty. Some artworks are here because they say something important about the way a color was used. Or simply because they are really amazing and I wanted you to see them.

2 Rocks, Minerals, Twigs, and Bugs

Tyrian PURPLE CLEOPATRA'S ROYAL COLOR

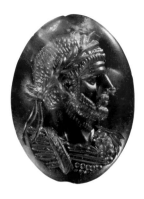

Portrait of Roman emperor Aurelian engraved on amethyst, Rome, 260–280

A French poster for the 1963 movie *Cleopatra,* starring Elizabeth Taylor, shown here wearing purple, of course.

The Romans conquered the Greeks in the second century BC and then proceeded to copy a lot of their ideas, their art, and even their gods—and certainly their colors.

Dozens of varieties of pigments and dyes were brought to ancient Rome, transported in galley ships, on donkeys, and on the backs of slaves. The most celebrated color was made from the macerated enzymes of a small shellfish, or, rather, from the macerated enzymes of millions of small shellfish. The color was called *purpura* (from which we get our word "purple"), and it was a fashion phenomenon. People in Rome adored this color with a passion we cannot possibly imagine today.

When Julius Caesar went to Egypt in 48 BC, he met Queen Cleopatra and was seduced by her and her magnificent lifestyle, which included sails dyed with purple, purple porphyry stone lining her palace (later the Byzantine emperors would copy the fashion, leading to the term "born in the purple"), and purple sofas. Caesar admired it all, and when he went home to Rome he decreed that only Caesars could wear togas dyed completely purple. And the only Caesar around, obviously, was Julius himself. But purple was an extremely expensive and extremely wasteful color. More than 250,000 *murex brandaris* and *murex trunculus* shellfish were needed to extract half an ounce of dye, just enough for a single toga.

Later on, the rulers of Rome fiddled with various bizarre regulations called "sumptuary laws" about who could wear what. Emperor Nero in the first century was adamant that, other than himself, of course, almost no one could wear purple without fear of execution. Septimus and Aurelian in the second and third centuries let women wear purple freely, but only high-ranking men such as generals and emperors could wear purple. And Diocletian, who reigned at the end of the third century, was really

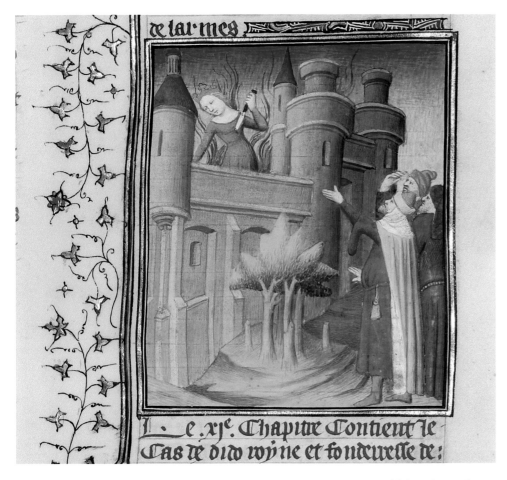

The Suicide of Queen Dido by the Boucicaut Master, France, about 1413–1415

Princess Dido was the daughter of the king of Tyre. In this illuminated manuscript she is shown dressed in the royal color for which her hometown was famous.

Engraved scaraboid, Greece, fifth–fourth century BC

This jasper gem from ancient Greece is carved with the impression of a murex shell, in celebration of the purple dye.

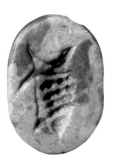

Pacific Purpura

Until recently, Mixtec women living in the mountain village of Tehuantepec, in Oaxaca State in Mexico, had only one fashion choice to make every morning: which of their striped purple skirts would they wear? They never wore anything but. The color came from *caracoles*, or sea snails, found 150 miles away on the coast. You didn't have to kill them. You just placed them on the raw cotton, waited until they had exuded a purple enzyme, and put them back on the rocks. In the old days the men used to walk to collect the purple on annual expeditions. By the 1970s they were taking the bus. Today the older women in Tehuantepec still wear purple striped skirts every day, though most are now dyed with modern chemical colors.

laid-back. He encouraged all his subjects to wear as much purple as possible, and he taxed them for the pleasure.

But purple stank. If you visit the town of Tyre in southern Lebanon today—where the color's historical name "Tyrian purple" comes from—you can see the ruins of the Roman city, all marble colonnades and graves and the wrecks of rooms that people once walked and joked and cooked in. And on the outside of town, downwind, is a row of rectangular stone vats as big as school lunch tables, and just as deep. These purple vats had to be outside the city walls because no one could live next to the horrible smell made by rotten shellfish soaking in stale urine mixed with wood ash and water. Even the clothes that had been dyed with them

had a distinctive odor of fish and sea. The historian Pliny called it "offensive," but for other Romans it was the smell of money.

The *purpura* color of ancient Rome was not necessarily the same as what we think of as purple today. Remember that a dye needs a mordant to make it stick. Depending on which mordant you use—tin, copper, aluminum, or urine—the result can be quite different. Tyrian purple, for example, can be rose colored, blue red, deep crimson, or velvety black. It can even, if you do the dyeing under the midday sun, be pale blue. There's a sample of wool in the National Museum of Beirut in Lebanon that is said to be dyed with Tyrian purple. It is bright pink.

Cinnabar, Vermilion, and Minium BEAUTIFUL BUT DEADLY

When they had won a fight in the Colosseum, gladiators in ancient Rome would sometimes be daubed in cinnabar paint and paraded through the streets. This very bright, shiny, orangey-red mineral was extracted from the mercury mine at Almadén in central Spain. It was a terrible place to work. Just a couple of years of breathing in poisonous mercury fumes could cause a slow and painful death.

The Romans knew how to make cinnabar synthetically (although it still required mercury from Almadén). We call this pigment vermilion, and artists used it until

the 19th century. Like cinnabar, it has the chemical formula HgS. Pliny called it "dragon's blood" and described it as the metaphorical struggle between a dragon (smoky yellow sulfur) and an elephant (heavy gray mercury). The "beasts" were locked in battle until their blood mingled to make mercuric sulfide—pure, rare, and dangerous. The ancient Chinese knew about vermilion 2,000 years before the Romans. They ground it into a paste and used it as the ink for official seals.

Vermilion was still not as hazardous as another bright Roman red. Minium is a vivid

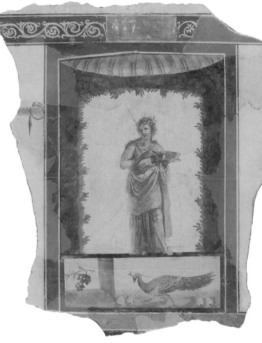

Above: Wall fragment, Rome, first century

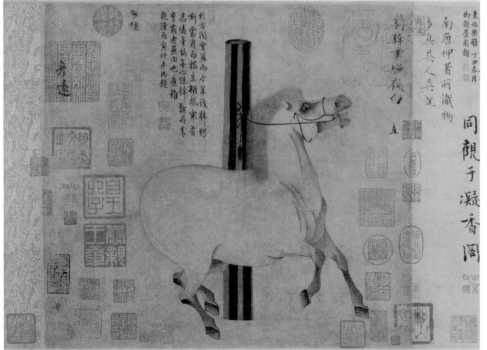

Left: *Night-Shining White* by Han Gan, about 750
Night-Shining White was the favorite horse of the Chinese emperor Xuanzong. All the red vermilion ink stamps you see on this handscroll were made by people who admired the painting. Many are the seals of emperors who owned it over the centuries, and several emperors (including the 18th-century Qianlong) even got out their calligraphy pens and wrote poems in black ink on the back.

Watch Out: Painting in Progress

It was the morning of August 24, AD 79, and three or four artists were hard at work in a house in the wealthier part of the Italian town of Pompeii. The artists had started their wall painting at the top and were working their way down. It was a picture of young men racing goat-drawn chariots in a grove of columns, flowers, and birds. The panels around the border were painted with ocher, which revealed that while the family was rich enough to employ professional artists, they could still probably not afford the fancier vermilion paint from Spain.

The artists were using a technique known as fresco, which was later very popular in the Renaissance (and seemed to be invented quite independently all over the world at different times, from ancient China to India, to pre-Columbian Mexico). In fresco, unlike in almost every other kind of painting, artists don't need a binder to fix their pigments into position. Instead, they mix the raw pigment with wet plaster and apply it straight onto the wall. It requires skill and speed, because if you lose concentration, the plaster will dry before you've finished.

Later that August morning, as the artists concentrated on their work, the world around them exploded. Mount Vesuvius erupted, completely covering Pompeii and several other towns, as well as many of their inhabitants, in volcanic ash and rocks. Perhaps, as the strangely light pumice stones

Wall painting fragment, Rome, about 9 BC–AD 14

began to fall around them, the artists hesitated for a moment. Could they dare to leave, when the plaster was still wet?

When houses in Pompeii were first excavated in the 18th century, it became popular in Europe and America to have a "Pompeian red" dining room. But red ocher is actually a dehydrated form of yellow ocher, meaning that extreme heat, say, from a volcanic eruption, could drive off the water in yellow ocher and turn it red. In 2011 scientists at Italy's National Institute of Optics presented a paper suggesting that up to half of the 246 apparently red ocher walls in Pompeii and nearby Herculaneum were actually yellow ocher before the volcano erupted.

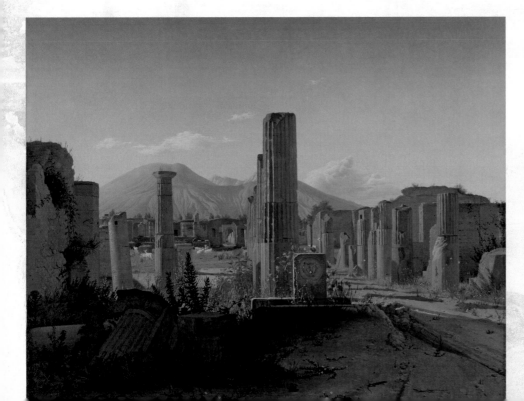

The Forum, Pompeii, with Vesuvius in the Distance by Christen Schjellerup Købke, 1841

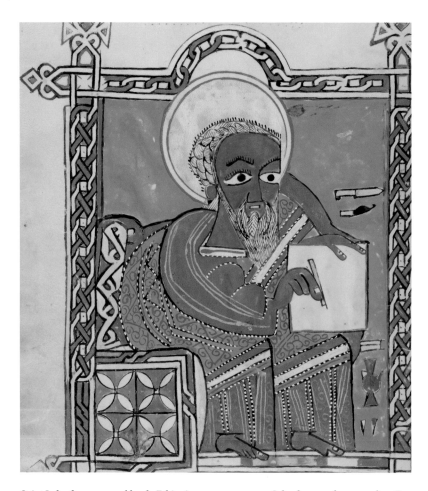

Saint Luke, from a gospel book, Ethiopia, about 1504–5

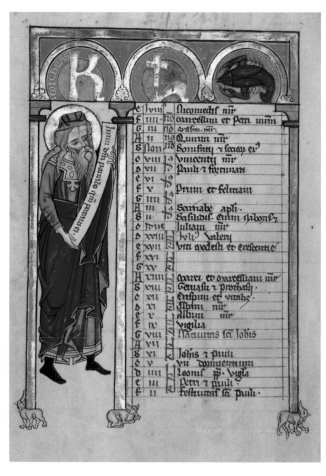

Calendar page from a psalter, Germany, about 1240–50
The expression "red letter day" comes from the medieval practice of writing special holy days in red ink.

Desolate nayika, India, about 1775–1800

orange color that seems to pop out of paintings with an optical "hello." The Romans used it for writing the initial letters or titles in their books, and since the paint showed up even on gold or marble, it was also used for inscriptions. "It is a well-known fact," Pliny wrote, "that even today, minium is in great esteem in Ethiopia, their nobles being in the habit of staining the body all over with it."

Minium's other popular name is red lead, and like other lead-based paints it is highly poisonous if it gets anywhere near the bloodstream. Medieval illuminators kept

it for lettering (the instruction bits of the Bible, such as "here ends the first epistle of Paul," were always "rubricated," or written in red), and many artists used it for bright clothes and the outlines of halos. Mughal artists in India and Persia in the 17th and 18th centuries liked it so much that their paintings became known as "miniatures," not because they were small but because of this trademark red paint.

Herakleides

Herakleides was about 20 when he died in Egypt at the end of the first century. His family gave him a good send-off. They preserved his body in many pounds of expensive tree resin (even today, dried by centuries in the desert, his mummy is so heavy it takes four men to lift it). And then they wrapped it in a linen shroud painted with magic symbols and goddesses. Over his head they placed a portrait of a handsome young man with a bare chest, signifying that Herakleides may have been a soldier or a priest of Thoth, the god of writing and magic.

When the shroud was analyzed at the Getty, scientists found the gold, carbon black, and lead white pigments they had expected. But there was also a green made from a mixture of yellow orpiment and blue indigo that art historians had thought was not invented until medieval times. The pigment that most intrigued the scientists was the minium (red lead) used for the orange-red background. By analyzing the isotopes (the number of neutrons in each atom of the pigment), they learned that it came not from anywhere near Egypt but from the Rio Tinto silver mine in southern Spain.

"We don't know for sure why it came all that distance," says associate conservator of antiquities at the Getty, Marie Svoboda. "We also don't know why, after the Egyptians had used red earth for thousands of years for their burials, they would suddenly switch to red lead." Perhaps it was the novelty, she speculates, or the fact that its toxicity made it a good pesticide. "Or perhaps it was just cheap."

Red lead is a by-product from the silver refining process. It is obtained by collecting the leftover impurities (litharge or lead oxide) and roasting them to high temperatures. You can imagine a beleaguered mine owner in Spain looking at all his leftover toxic waste and wondering what to do with it. Then he discovers that heating it turns the ugly gray material a beautiful bright red, and not only that, there's a market for it in Egypt and boats might even carry it cheaply as ballast. Several "red-shroud mummies" have been found in Egypt, and so far analysis has found that the red lead from most of them came from this same source in Spain.

In ancient Egypt, red was a very powerful color, and it could be either good or bad. On the positive side, it was associated with the sun god Ra. On the negative, it was associated with the frightening desert lands beyond the safe places where people lived. The English word "desert" comes from the ancient Egyptian *desher*, meaning "red."

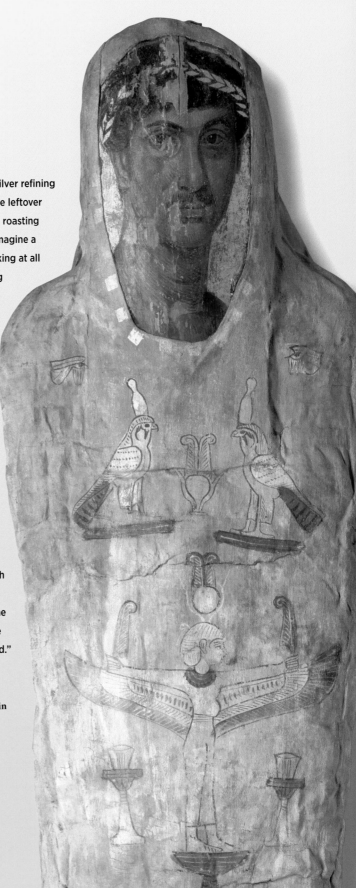

The mummy of Herakleides, who died in Roman Egypt around AD 50–100

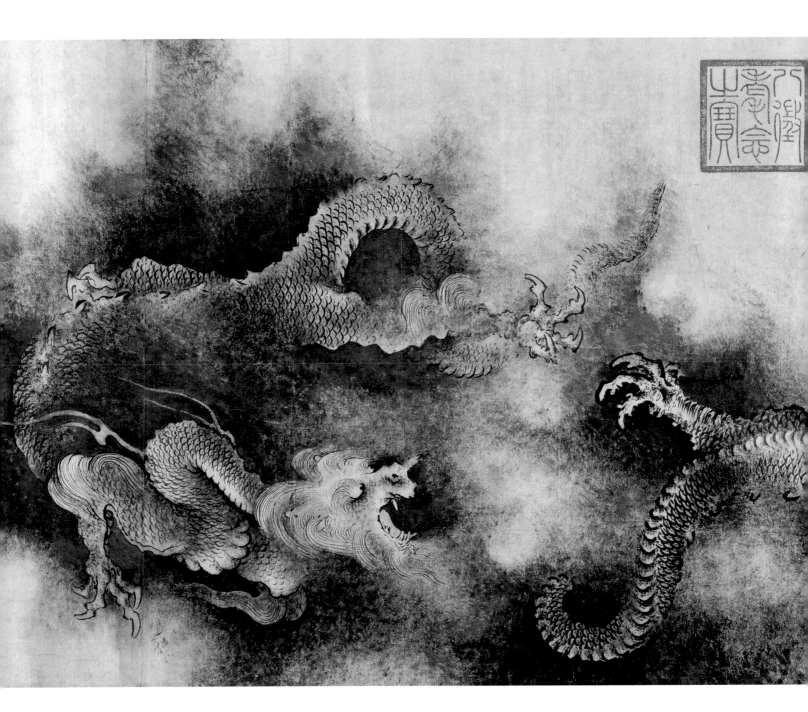

BLACK Ink WHO NEEDS COLOR ANYWAY?

Nine Dragons by Chen Rong, 1244

When Chen Rong finished this 8-foot-long ink painting *Nine Dragons*, he gazed at his own work in amazement. "At a distance one feels as if the clouds and waves are flying and moving. Viewed closely one feels that only a god can have painted these dragons," he commented, not very modestly.

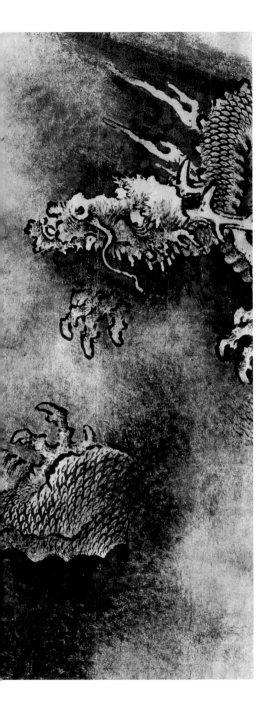

No one knows when ink was invented, but by 4,000 years ago it was in use in both Egypt and China as well as in various places in between. In Egypt, black ink was made of soot, mixed with gum to make it stick. In China 1,500 years ago, the best ink was made by burning oil lamps behind a bamboo screen: every half hour, workers would remove the soot from the lamp funnels using feathers. The Tang dynasty (618–907) was a time when Chinese art flourished. Most artists painted fine black lines and filled them with color, but then one man, Wu Daozi, decided to use only black ink, with free strokes that seemed to come from his heart more than his mind. His paintings were thought to be amazing and exciting, as if the black ink contained all the colors already. From then on in China, monochrome, or one-color, paintings were seen as more sophisticated than ones with many colors. In the 11th century the scholar-artist Su Dongpo painted a picture of a bamboo plant using red ink. He was criticized for not being realistic. "Then what color should I have used?" he asked. "Black, of course," came the answer.

Sacred Writer by Alex "Defer" Kizu, from *LA Liber Amicorum*, 2013

The artists' book *LA Liber Amicorum* binds together artworks from more than 150 of Los Angeles's leading graffiti and tattoo artists. The title and spirit of the book came from a 400-year-old manuscript at the Getty Research Institute, a *liber amicorum* (book of friends), which multiple artists filled with coats of arms, watercolors, poetry, and calligraphy as mementos for the owner. Defer's drawing for the *LA Liber* connects to the even older Chinese tradition of monochrome ink composition.

GOLD MEDIEVAL RADIANCE

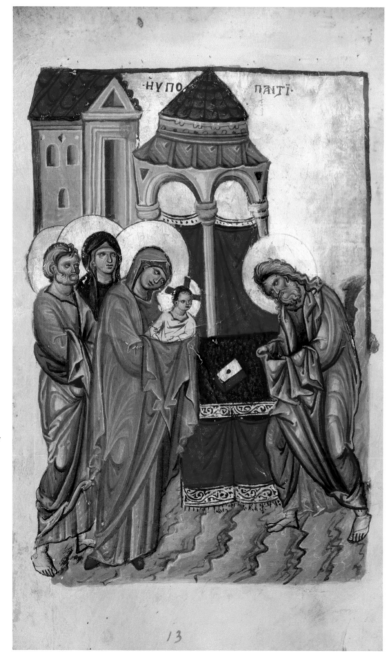

The Presentation in the Temple, Byzantium, now Turkey, 13th century "Icon" simply means "image." And although we often think of icons in art as paintings on wooden panels, they can also be embroidered on textile, incised in metal or—like this one—painted with pigments and gold leaf on parchment.

It was a riot. Angry mobs rampaged in the streets, trampling paintings underfoot and smearing them with excrement. Pictures are against the teachings of God, they shouted, as they burned another painting in the public square. This was eighth-century Constantinople (now Istanbul). And those iconoclasts— breakers of icons, or religious images—were Christians encouraged by the Byzantine emperor Leo III himself.

A council of bishops in 754 agreed that painting people and living creatures was a blasphemy. The paintings encouraged people to venerate pictures rather than God, and it went against the second of the Ten Commandments in the Bible: "You shall not make for yourself a graven image, or any likeness of anything that is in heaven above, or that is in the earth beneath, or that is in the water under the earth." More images were destroyed.

These days we grow up with so many pictures everywhere it's hard to see the fuss. They're in or on phones, computers, books, billboards, buses, cereal boxes, our shirts; they seem part of the surface of life. But in the eighth century just about the only pictures European people ever saw were in churches (where, admittedly, they covered every wall). And almost no one could read, so pictures had more significance.

In 834 the bishops met again, and this time they came down on the side of art. They decided that the purpose of icons is to help people meditate on great unknowable things. And that by using natural materials (rocks, flowers, leaves, eggs, and bones) to make their

paints, icon painters were celebrating the natural gifts God had given and so they were praising him through the very material of their artwork.

It's easy to look at icons and the medieval paintings that came later and think how simple they are. They don't have shadows (take a look—they don't) and most don't have much sense of perspective, or distance within the painting, either. The colored pigments aren't blended with each other on the palette; they're applied pure or mixed with white in a series of tiny strokes, the width of an eyelash. It's almost as if the paintings were mosaics.

The Greeks and Romans had been able to handle shadows and perspective and color mixing. We can see all those things at Pompeii and in the mummy portraits. So what had happened? Had artists forgotten everything? The answer is that icon artists didn't use shadows or perspective because they felt they didn't need them. Why? Because icons weren't *supposed* to be copies of anything in this world. Like the "icons"

on our computers, they were meant to be representations, not realistic depictions. The imagery of religious icons was a kind of code to understanding the supernatural.

So when you look at icons of buildings and you can't figure out whether the viewer is supposed to be really tall or really small or standing to the left or to the right, that is because you are supposed to be experiencing how God "sees" the whole world all at once. And none of the people have shadows, because it was believed God doesn't see shadows. (And you probably wouldn't, either, if you were made up entirely of light.)

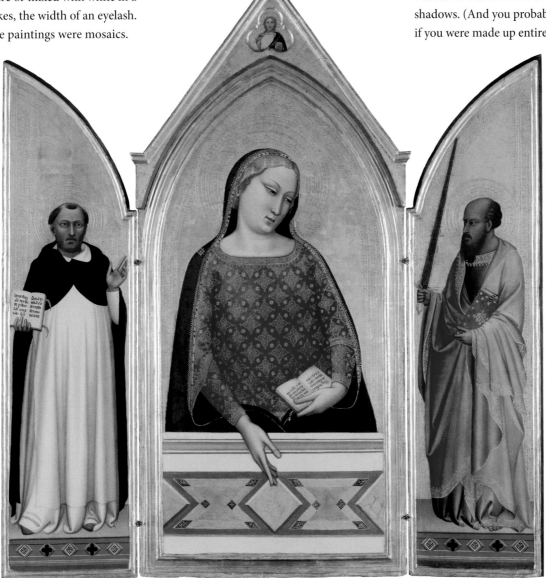

The Virgin Mary with Saints Thomas Aquinas and Paul by Bernardo Daddi, about 1335

The choice of colors and paints is another code. Red means victory over death, as well as power and royalty (which came down from that Roman passion for purple). Blue is for mystery, green is for life, and white is for purity. But the greatest of all the colors in art at that time was gold.

Gold is difficult to grind as a pigment, because the pure metal is so soft it doesn't easily break into particles that can be suspended in a binder. So instead it was mostly hammered into extremely thin leaf. After nuggets of gold were beaten down to about 4 millionths of an inch (that's a quarter of a million leaves required to make a 1-inch-high stack), this thin leaf needed something to make it stick to the surface of a painting. Sometimes artists used honey, but mostly they used rabbit-skin glue mixed with a fine brownish-red clay from Armenia, called "bole." Sometimes the gold leaf was left smooth, burnished with an agate stone, and sometimes it was embossed with a little pointed tool to give a texture. And other times artists would paint over it with another color and then scrape away some of that paint with a knife to let the gold shine out from underneath. That was called *sgraffito*, from the Italian word for "scratch," and the slightly uneven surface that came from one layer being above another would scatter the light so it would appear to shimmer.

Former senior curator of paintings at the J. Paul Getty Museum Scott Schaefer tells a story about visiting a friend in Paris who is a dealer in 14th-century art. The friend asked him to dinner, "and I said I would go, on condition that he let me visit his gallery at night, and that we see the paintings by candlelight." Most early Renaissance paintings were designed to be viewed by the flickers of candles in a dark church, and Schaefer had always wondered what that would look

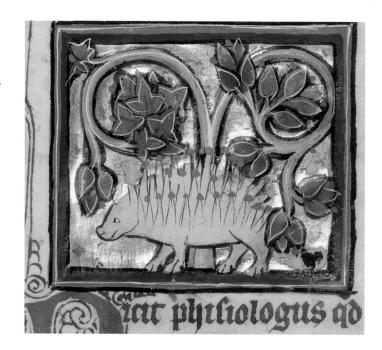

A hedgehog on a gold background, from *On the Nature of Birds*, France or Flanders, about 1275–1300

like. "It was a revelation to everyone," he said, describing how the flames made the pictures shift and dance as if they were animated. And the paintings with areas of pure gold (and in 14th-century Italian Renaissance art that is most paintings) shone in a way he had not expected. He said some of the brushstrokes, which in daylight or electricity look ordinary, appeared to be lit from within. "It was one of the great experiences of my life."

Fire regulations and insurance companies would never let this happen at a museum, but we can imagine. And if we are to look at medieval and Renaissance art with a fuller understanding of the colors used in them, then we have to imagine—because nothing would say "this is sacred" to a pre-16th-century European more than art that glowed with gold.

Turnsole

In the south of France there's a flower whose head follows the sun across the sky. In the Middle Ages, manuscript artists used to squeeze its seeds and then dip pieces of cloth in the juice. All they had to do later was moisten the cloth with liquid and color would drop onto their palettes. But here's the strange thing: the color was different depending on what liquid they chose. If they used plain water, they had purple, and if they used something acidic like lemon juice, they had red. But if they put alkali on the cloth, then they got a powder blue. Turnsole (from the Latin for "turn to the sun") is rarely used now, as it isn't stable in sunlight. But there's a famous algae from Scandinavia that has the same quality. It can be found in every chemistry lab in the world, used to test if something is alkali (when it turns blue) or acid (when it's red). It is called "litmus," after the Norse word for "to color."

GREEN Earth UNEARTHLY UNDERTONES

Boys Hauling Nets from the Abbey Bible, Italy, about 1250–62

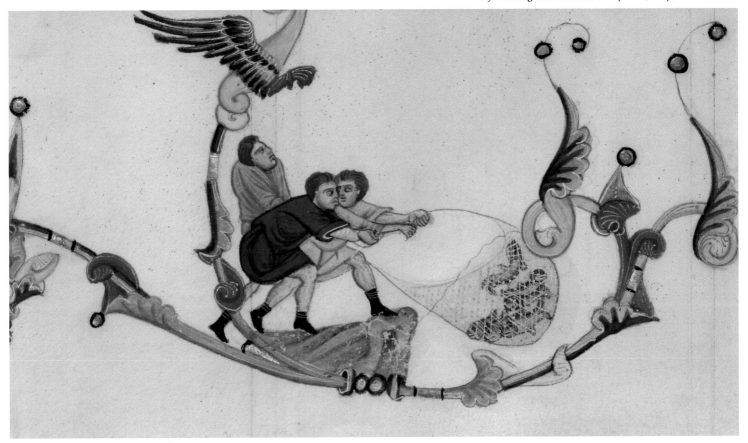

Around 1351 the Italian artist Cennino Cennini wrote the first Western "how-to" book for artists. He had learned from the best—his own teacher was taught by the great artist Giotto di Bondone—and he wanted to pass on the knowledge before it got lost. He told readers so many of his secrets (how to mix glues using lime and cheese, as Giotto did; how to touch up panels with gilded tin to make them look old; how to cook up green with a decent wine vinegar)

that ever since Cennini's manuscript was rediscovered in a back room of the Vatican in 1821, *Il libro dell'arte* (The Craftsman's Handbook) has not gone out of print. It has been extremely useful for artists, restorers, and historians . . . and also for forgers. The 20th-century British art forger Eric Hebborn often used Cennini's advice to make his "old" masters seem authentic.

He had a sense of humor, Cennini, and likened the process of adding glue onto a

wooden panel to a hungry man drinking a glass of wine after a fast: you have to start with a little bit, to allow it to absorb, before having the whole meal. In painting, getting the flesh tones right is important. And when using egg yolk as a binder, in the style called "tempera," the trick was to start not with pink or brown but with green. "Take a little green earth and a little white lead," Cennini advised, "and lay two coats all over the face, over the hands, over the feet, and over the

nudes." He said the best binder for pigments used to paint the flesh of young people is made from the "yolks of a town hen's egg because they are whiter," while portraits of older people should be painted with pinker yolk from country hens. You can see the green earth under the faces and hands in many Renaissance paintings. Sometimes, the pink on top has faded, and the green is all you see, which gives a rather strange effect, as if someone is about to be sick.

The 14th century was the right time for a book like Cennini's, since the art market was about to explode. Florence and Siena had become wealthy from banking and commerce, and a new superrich was emerging in Europe. The newly wealthy thought of themselves as cultured and educated, and they were therefore desperate to show other people just how cultured and educated they were. One of the ways they did this was by commissioning art. At first they paid for art to be displayed in churches, making sure it had their names written on it somewhere or that there was a portrait of them among the saints.

But then something changed. Painted art moved into private homes. Wealthy medieval homes had long had tapestries, hung on the walls both to decorate and to keep out the cold. Unicorns, knights in shining armor, dragons, battle scenes, and maidens were particularly popular. But by the 14th century tapestries seemed old-fashioned. Rich people wanted something more: a portrait or two, a painted battle, or a naughty scene from mythology. The pleasure of art ownership was about to begin, and new uses of color were called for.

RED OCHER
Sometimes it's found in the earth like this, already red. But sometimes it's yellow ocher that's been burned.

YELLOW OCHER
A prehistoric pigment, named after the Greek for "pale earth."

Stuff In This Book

GREEN EARTH
An artists' color since at least Roman times. In medieval and Renaissance Europe it was used as the first layer for faces, with some surprising results.

VINE CHARCOAL
"Then there's black made from vine twigs; when these twigs are burned throw water on them, and quench them … and it is one of the perfect colors." —*Cennini*

KAOLIN
This clay was the essential ingredient for porcelain. At one point there were dozens of European spies racing to find the Chinese secret.

MALACHITE

If you cut it in half, it resembles a toad's skin, full of strange bubbles. You can't grind it too fine, or it looks gray when you paint with it.

COCHINEAL

Dried cochineal bugs make a very bright red. They came to Europe from the New World in the 16th century.

AZURITE

Sometimes artists would paint lower layers with this copper-blue rock and put the more expensive ultramarine on top to save money.

GUM ARABIC

This is collected from the bark of acacia trees in African deserts. When you mix it with pigment it makes watercolors. Today, though, the big business is in soft drinks, chocolates, icing, and sweets: it's like an edible glue.

MADDER ROOT

As a dye this is deep autumn orange; as a pigment (made to a secret recipe), Rose Madder Genuine is a strong powder pink.

INDIGO CAKES

Indigo came from India and in the 15th century was sold as little beans.

LAPIS LAZULI

This stone came from a remote mountain in Afghanistan. The best kind is so blue it is almost violet.

SAFFRON

The most expensive spice in the world: it makes a red food coloring, and mixed with egg white it was used in medieval manuscripts as a cheap alternative to gold color.

GOLD LEAF

Beating gold into leaves this thin would take strong men with mallets many, many hours.

SMALT

A pigment made of ground-up blue glass. J. M. W. Turner is said to have used it in great quantities in the 19th century.

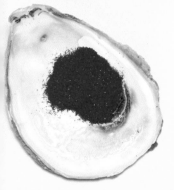

BRAZILWOOD

The country of Brazil was named after this wood when the Portuguese found it growing there. It was used for red dye. Boiled with lye and rock alum, it makes a very lovely pink.

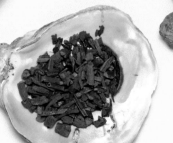

OAK GALLS

Made by wasps laying their eggs in oak trees. When they are made into ink the color comes out gray, but as it oxidizes on the paper it turns black.

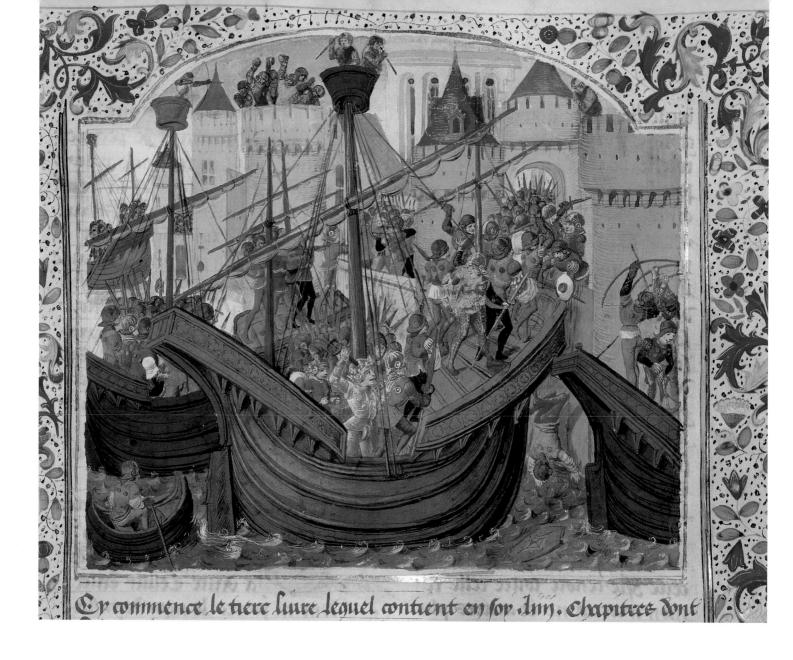

The Age of CANVAS
PAINTING ON SAILS

What would it be like if a teenager who loved gadgets was given access to the country's financial reserves? In about 1410, Portugal began to find out. Their third-oldest royal prince almost bankrupted the country with his inventions, but he also opened up the Age of Exploration and by accident changed the course of European art history.

His name was Henry and later he would be known as Henry the Navigator, even though he would actually navigate himself no farther than the north coast of Africa. But in 1410 he was 16 and a dreamer, fascinated by how nobody had ever tried to sail from Europe to India or China. Until then, all the trade routes to those places went overland. The ships Henry had grown up with were no good: they only had one mast and fixed square sails, and their bottoms were pretty flat. They could scarcely brave a storm in the

Left: *Alexander Attacks the City of Tyre* by the Master of the Jardin de vertueuse consolation and Assistant, about 1470–75

By the time this was painted in the 1470s, ships had several masts.

Adoration of the Magi by Andrea Mantegna, about 1495–1505

This is an early painting on fine linen canvas.

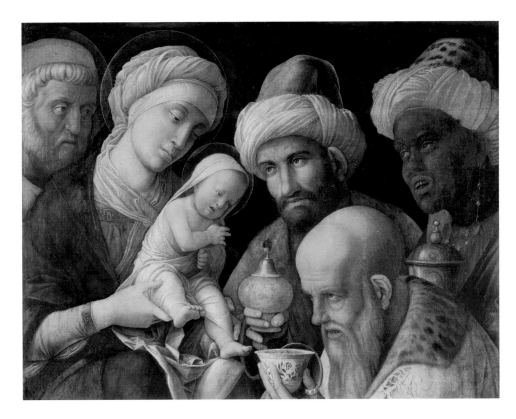

Mediterranean and were hopeless against the violent Atlantic swells.

So, in an initiative that was as audacious in its time as the Apollo Space Program 500 years later, Henry started to redesign the ships. He experimented with everything. He improved the strength of the ropes, added masts, and increased the size of the holds so his new souped-up ships could carry more cargo. He improved the quality of the sailcloth, too, making the vessels stronger in storms.

The English word "canvas" comes from the Latin *cannabis*, meaning the "hemp plant." Thousands of years ago the Greeks, Romans, Chinese, Indians, Scythians, and others knew all about the plant's psychoactive qualities, but they cultivated it mainly for its dried stem, used to make ropes and sails and rough brown sackcloth. Classical artists had used it on rare occasions: there was a famous story that Emperor Nero commissioned a portrait of himself on a 120-foot-high hemp canvas, the height of a 10-story building, but it was struck by lightning before it could go on display. But hemp canvas was rough, with little knobbles in the weave that made an annoying surface for painting, and it never really caught on. Wooden panels were just easier to handle.

Henry's new sails were made of a different fiber: flax, which the Greeks called linon. It was finer quality and did not stretch: we get our word "line" from it, referring to how a flax thread can be pulled taut between two points to measure the shortest distance between them. And when Europe's seafaring nations realized what a difference linen sails made to their fleets, they started to produce them in massive quantities. Making the new triangular sails (another invention by Henry) left plenty of small offcuts, and it is no surprise that artists began to pick them up, particularly in port cities like Venice. Linen was less bumpy than hemp and altogether easier to work with than wood: lighter to carry and easy to cut and frame and hang on private walls. And when prepared or primed carefully, with gesso and glue "size" and plenty of rubbing with bones and sticks over several days (the 16th-century artist

Albrecht Dürer once wrote that if he hurried, he could do it in eight), the new linen "canvas" made a surface for art that has not really been improved on since.

For canvas the best binder was not egg anymore, but oil, which came from walnuts, poppy seeds, safflower, or linseed (another product of flax), which all took ages to dry between layers but made the paintings look so good most people thought they were worth the wait.

So, at the time explorers such as Bartolomeu Dias (the first European to sail around the southern tip of Africa, in 1488) and Christopher Columbus (who led the first expedition to the Americas, in 1492) were still young children, artists throughout Europe were beginning to use sailcloth to explore a new way of painting—with oil on canvas, the way many people still do it today.

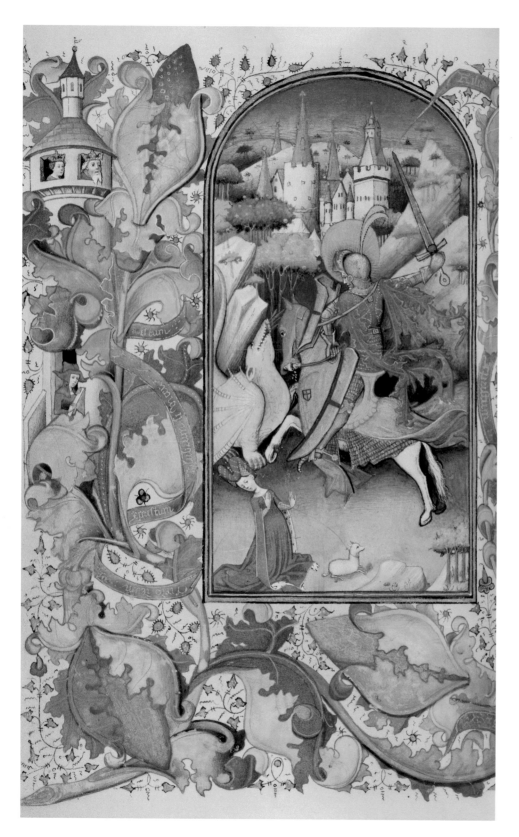

Ultramarine

FROM THE VALLEY OF THE STONE

Saint George and the Dragon by the Master of
Guillebert de Mets, about 1450–55

You might look at a work of art and think
"how clever" or "how beautiful" or "I
wonder how they did that." But do you
ever look at a section of a modern painting
and think, "Now that bit was expensive to
make!"? That's how people in the Middle
Ages and Renaissance used to look at art. An
area of gold showed them immediately that
they were looking at something really pricey.
And there was another color that said the
same thing: ultramarine blue, made from the
semiprecious gemstone lapis lazuli.

For years I thought ultramarine was so
named because it was the color of the sea,
which seemed strange, because in paintings
it is more often used for the sky. But although
"marine" does come from the Latin for "sea,"
ultra means "beyond." "Ultraviolet" refers to
the light waves that are "beyond" violet (and
since violet is the tiniest wavelength humans
can see, these are just beyond what we can
detect with the naked eye). So "ultramarine"
means "beyond the sea," and the color was
named for where it came from. For centu-
ries all the ultramarine pigment in the world

came from a single range of mountains in Afghanistan called Sar-i Sang, the "Valley of the Stone." In the past miners used to light fires under blue seams in the rock, and when the surface was hot they would throw icy water over it to shock the stone into cracking. Sometimes the men would have to run quickly to avoid a fall of rubble, and the smoke would have been noxious. Today you can still see how the first few hundred yards of the shafts are black with soot from fires that in some cases were lit thousands of years ago.

Engraved lapis lazuli gem, Rome, second century

It is also astonishing to think that 6,000 years ago Egyptian traders were importing this pretty blue stone 3,000 miles across some of the world's toughest terrain. When it arrived it was worth a fortune. People would set it into jewelry and headdresses, to show how incredibly wealthy they were. But the ancient Egyptians never worked out how to make it into decent paint. You can't just grind it up and add it to a binder. Lapis has so much other stuff in it—pyrite, calcium, diopside, forsterite, wollastonite, and muscovite—that it's hard to extract just the blue. In 1916, an expedition from the Metropolitan Museum of Art in New York unearthed a fragment of a statue of a Third Dynasty Egyptian queen (from around 2600 BC) with traces of lapis on her

Page from a manuscript of the Qur'an, Iran, about 1550–75

collar. The stone had been ground up and suspended in something like acacia gum, but it made a really poor blue, a gray really.

It was not until 3,000 years later that someone figured out how to make lapis into a proper pigment, and the process was so tricky it was kept secret for a long while. The first time it is known to have appeared was on frescoes around the head of a gigantic sixth-century Buddha sculpture, in the valley of Bamiyan in Afghanistan. (Most of these frescoes are gone now, blown up with the Buddhas by Taliban fundamentalists in 2001.) When the secret arrived in Europe a few centuries later, it was a sensation. All churches wanted ultramarine in their paintings; it became the most prized color in Christendom.

When artists and monks (which in Europe in those days were often the same thing) color-coded the figures in the New Testament, they made Judas yellow to symbolize his betrayal of Christ, and they often showed martyred saints in red, to represent all the blood they spilled during their horrible deaths. But because ultramarine was so highly valued, they painted the Virgin Mary's robes with the first-quality Afghanistan blue, to show she was the most precious of all.

The Annunciation by Simon Bening, about 1525–30

The "Piebald" Horse by Paulus Potter,
about 1650–54

Why Is the Sky Blue?

Imagine you're at the beach watching waves rolling in from the ocean. If the waves meet a large rock, then almost every wave will be diverted by the rock. If the rock is smaller, only the medium-size and small waves will have to stop; the big waves will just roll over it. And if the beach is covered in little pebbles then only the very tiniest, gentlest, scarcely noticeable waves will have to change their course to go around them. This is kind of like what happens to sunlight as it passes through Earth's atmosphere. It is the smallest wavelengths, which are the blue and violet (and ultraviolet) ones, that are most sent off course ("scattered") by the thick layer of tiny air molecules that make life on our planet possible. Longer green and red wavelengths are scattered too, but nowhere near as much as the blue wavelengths, which end up giving our skies their lovely azure hue. When sunlight is passing through the most atmosphere, as at sunrise and sunset, or when certain other obstacles are present (like salt particles near the sea or debris from a volcano), all that scattered blue light and even some of the green light is either absorbed or completely scattered away, coloring the sky with brilliant shades of crimson and orange.

French Ultramarine

In 1824 a French society offered a prize of 6,000 francs to anyone who could synthesize ultramarine. The real pigment from Afghanistan was more expensive than ever, and, even worse, the British in India had too much control over its trade routes. Two chemists came up with a solution at exactly the same time: Jean-Baptiste Guimet of France and Christian Gmelin from Germany. But Guimet was French and he won the prize. His discovery was called French ultramarine to distinguish it from the natural pigment.

The Death of Lara by Eugène Delacroix, about 1824

Secret Recipe for Ultramarine Blue

First take a chunk of the best lapis lazuli. Remember for a minute just how expensive it is, so you'll treat it with respect. Pound it with a bronze mortar, covered up so the dust doesn't float away. Then put it on a slab, and work it up. Sieve and pound again. And again. And again. Melt pine resin, gum mastic, and wax in with the blue. Strain with a linen cloth, and make a dough. Grease your hands with linseed oil until they are really slippery, and work the dough every day for three days and three nights. Don't rest yet. Then pour water into ashes, and add it (it is called "lye," and it is alkali) to the dough in a bowl. Take two sticks and, with one in each hand, squeeze the dough as if you were making bread. When the liquid is saturated with blue, drain into a glass bowl. Then take more lye and repeat with a new bowl. Keep doing it until the dough has no more color to add. Put the bowls in the sun to evaporate the water until you have a blue powder, and the first bowl will be the best and the last bowl will be ultramarine ash, good only for glaze.

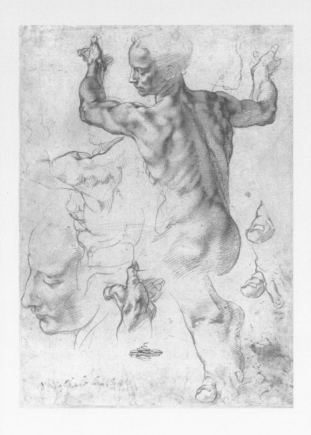

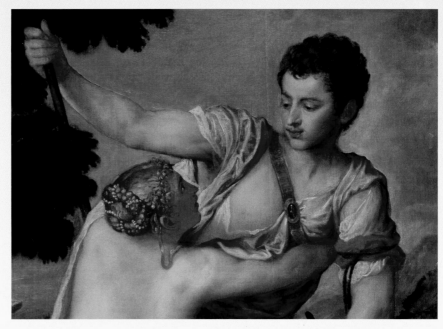

Studies for the Libyan Sibyl by Michelangelo, about 1510–11

Venus and Adonis by Titian, about 1555–60

The Great Debate

So this great Florentine artist called Michelangelo goes to Rome to meet his rival, the Venetian artist Titian. He sees Titian's latest painting. "What was it like?" a friend asked Michelangelo later. "Nice colors," he answered. "But I do wish the Venetians were better at drawing."

This anecdote, told in a more literary way by writer Giorgio Vasari—who was there on that day in 1545—illustrates a major debate in 15th- and 16th-century art. It is referred to (even in English) as *disegno* vs. *colorito*, which can nearly, though not quite, be translated as "drawing vs. color." *Disegno* refers to the use of drawing for planning a composition, which often involved extensive study of nature, anatomy, and movement. *Colorito* is an approach based on the layering and building of color to form the composition, which was often worked out directly on the canvas.

And so the question that obsessed artists and the people who wrote opinions about art (because the Renaissance was the time that art theory was born) was, which is better? Put in the lines first and color later? Or start with a free and expressive sense of what the picture should look like, using colors to work out the light and the shapes before you fill in the details?

In the 1960s neuroscientists looked at the two hemispheres of the cerebral cortex, the bit of the brain where rational function happens. By watching what patterns of behavior are affected when one or the other of them is injured, they realized the two sides operate differently. The left brain does the analytical thinking: it likes words and numbers and lines and monochrome. It is the critic. The right brain is the chaotic, fun-loving, color-loving, visual, spontaneous side that can't

organize its way out of a paper bag. I like to think of *disegno* as left brain and *colorito* as right brain. That still doesn't answer the question of which is better. Do you prefer creative order or organized chaos? Are you *disegno* or *colorito*? Or do you, like Leonardo da Vinci, mix the two, and use drawings to brainstorm in a chaotic way?

The important thing to remember is that there is no correct answer. You need some of each to make a creative work of any kind, whether it's a painting, a song, a video game, or a novel. Michelangelo was a little more *disegno*, Titian a little more *colorito*. And they were both brilliant.

Cochineal A NEW WORLD COLOR IN ART (AND YOUR LUNCH)

A quipu messenger reporting to the ruler of the Inca, in *General History of Peru* by Martín de Murúa, 1616

In 1553, the overlords of Tlaxcala in central Mexico were worried. Since the conquistadores had arrived 50 years earlier, there had been so much demand in Europe for a particular red dye that none of the native farmers were doing anything but growing it. "Things are no longer as they were long ago, for the cochineal cactus is making people lazy," read their report. "No longer is care taken that maize and other edibles are planted. . . . Because of this now many fields are going to grass, and famine is truly threatened." Each person was limited to tending just 10 cacti, but the orders from abroad kept pouring in.

Cochineal is a bug, the size of a child's smallest fingernail, that grows on a particular cactus variously called *Opuntia*, "nopal," or "prickly pear." An infestation of these bugs looks like white snow on the cactus paddles, and in the end it kills the plants. But when dried and crushed, cochineal makes an astonishing color.

The Maya and Aztecs used it in dyes and cosmetics as well as for medicine and painting. Farther south, in Peru, the Incas used it for messages. They hadn't invented writing but instead developed a complex system of colored, knotted cords called quipu that were carried across the country by messengers on foot. Black knots denoted time, yellow meant money, blue was for the gods, and red meant the Inca armies. If you sent a red and black cord with certain knots the recipient would know there had been a battle, where and when it had taken place, and how many soldiers had died.

Throughout the 16th century between 50 and 160 tons of cochineal were exported to Europe every year. It was the third most valuable import from the New World, after gold and silver, and it was so celebrated that twice a year, when the ships came into the port of Seville on the trade winds, people would dress up and dance in the streets. There had not been a great dye like this one since Tyrian purple. There were other reds, of course. For centuries people had gone searching in oak groves for wild kermes insects that could be crushed to make a red dye, from which we get the English word "crimson." But it was one-tenth the strength of cochineal, and kermes insects were hard to find. There was also madder from a special root, which we will meet later, but that was more orange. Cochineal produced a strong dye at the very center of redness. The Spanish could have called it "tomato red,"

Prickly pear cactus infested with cochineal

Portrait of a Young Man in Red by the Circle of Raphael, about 1505

Portrait of Isabella of Portugal by the Workshop of Rogier van der Weyden, about 1450

Isabella of Portugal was the younger sister of Henry the Navigator. When this portrait was painted, she was living in Burgundy, now northern France. A red dress would have been dyed with crushed kermes insects, which was the only rich red dye available in Europe before cochineal.

In the past the fabric you wore was a sign of how wealthy you were, so artists who could paint luxurious textiles had rich people lining up for portraits. Here are some tips for painters from 14th-century Italian artist Cennino Cennini: "If you want to get the effect of a velvet, do the drapery with any color you wish, tempered with egg yolk. Then make the appearance of cut threads in the velvet using a miniver brush (made from the tail of a squirrel), in a color tempered with oil; and make the cut threads rather coarse." For making something in a wall painting look like wool, he advised going back after you've plastered, smoothed, and otherwise finished the painting and then "take a little block, not much bigger than a checker playing piece and, sprinkling clear water over this part with the brush, work over it, around and around. . . . The mortar gets rough and poor surfaced. Let it stay so, and paint it as it is, without smoothing down. And it will really look like woolen cloth."

except that in the early 16th century they hadn't yet heard of tomatoes, another Aztec agricultural product.

Cochineal was a dye, but artists in the 16th century soon discovered that, like other organic dyes from plants and insects, it could be made into a useful paint. Paint made from cochineal was called "carmine." Raphael used it, and Leonardo da Vinci. It made a rich cherry-red glaze when painted over other reds, including vermilion. But lakes are usually fugitive. They fade if exposed to light, and that can sometimes be disastrous. The

18th-century English society artist Joshua Reynolds unfortunately used it as the main pink for skin. Many of his subjects now look like weird, pale-faced ghosts.

Cochineal is still used, not often in dyers' vats or artists' paint boxes but in food and makeup. Manufacturers use it because it's one of the safest colors around. So if you put on lipstick, eye shadow, or blusher, or if you eat certain soups or cheeses or processed ham, then you probably have experienced the tomato-red extract of that bug from South America.

Martagon Lily and Tomato by Joris Hoefnagel, illuminator, and Georg Bocksay, scribe, 1561–62, illumination added 1591–96
This is one of the first known paintings of a tomato. Europeans were initially afraid to eat tomatoes. The plants are members of the deadly nightshade family and were thought to be poisonous.

An Oriental Potentate Accompanied by His Halberd Bearer by Jusepe de Ribera, about 1625–30
This drawing was made with carmine ink.

Vandyke Brown

Anthony van Dyck was 16 when he set up
as an independent painter in 1615, with
his friend Jan Brueghel the Younger, who
was 14. Van Dyck was already a skilled
artist. His teacher, Peter Paul Rubens, said
he was the best of all his pupils. When
Van Dyck was 21 he got a commission
to work for King James I of England.
He used reds and other bright colors,
but he also used browns—particularly a
transparent glaze made from Cassel earth
from Germany—mixed with bitumen,
which is the sticky tar substance used on
roads. It gave the paintings a nice shine,
though it would also make them darken,
and, sometimes, when other artists used
it too thickly, it would make paintings
appear to melt. A century later this color
was called "Vandyke brown" in his honor.

Portrait of Agostino Pallavicini by Anthony
van Dyck, about 1621

Logwood BLACK PURITANS AND PIRATES

Where do pirates go when they retire? In 1667, a peace treaty between England and Spain forced hundreds of English buccaneers into unemployment after decades of robbing Spanish vessels of their gold and silver. Many of them went into the dye business.

Northern Europe was full of Protestants who liked to wear really dark black to show how really pious and serious they were. The trouble was that black dye was tricky. Cheap dye, made of oak galls, would fade to orange within weeks; walnuts and blackberries made an unsatisfactory dark gray. So apart

from a hugely expensive method of triple dipping (in blue, yellow, and red dye vats, to ensure all the light is fully absorbed by the fabric), the best way to get a dark black was the simpler combination of indigo and a dark red dye from the heartwood of trees that only grew in Central America: logwood.

Until 1673 England had a law banning the use of logwood because too much profit went to Spain, which owned all the areas where it grew. But once England and Spain were at peace, and England had claimed a few thousand square miles in what is now Belize

(then British Honduras), the market opened up again. Logwood grows deep inside mangrove swamps, and it was tough work to get it out. During the wet season the dye collectors would step from their bed platforms into 2 feet of water and continue standing in the wet all day as they chopped and cut. And the mosquitoes were terrible. No wonder that, when the merchant ships arrived, the logwood men would go on a bender for days, until they had spent all their money. It was ironic that the color worn to show seriousness and godliness among Puritans and other Protestants in Europe and America was bought from men who spent all their profits on rum, women, and partying.

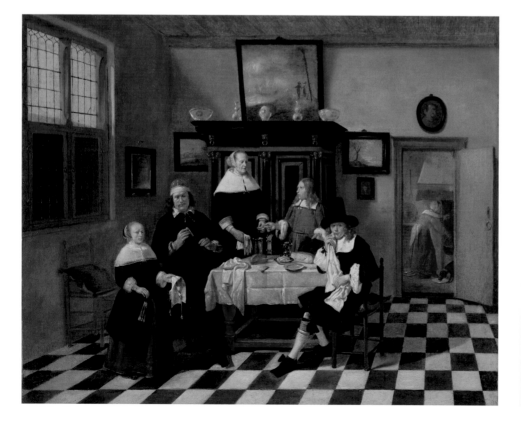

Family Group in an Interior attributed to Quiringh Gerritsz. van Brekelenkam, about 1658–60

Captain Teach Commonly Call'd Black Beard from *A General and True History of the Lives and Actions of the Most Famous Highwaymen, Murderers, Street-Robbers*, 1742

The Woman Taken in Adultery by Han van Meegeren, about 1941–42, right, on display at the Boijmans Van Beuningen Museum, 2010
 Compare this painting to the work by Vermeer on page 70.

Porcelain lidded vase, China, about 1662–1722

Cobalt BLUE AT THE SCENE OF THE CRIME

In 1943 the Amsterdam art dealer Han van Meegeren sold an old master painting to Nazi field marshal Hermann Goering. *The Woman Taken in Adultery* was an unknown work by the great 17th-century painter Johannes Vermeer and incredibly valuable.

Except it wasn't, because Van Meegeren was actually an art forger, and his "Vermeers" and "Pieter de Hooches" had tricked some of the greatest art experts of the time. In 1937, his version of Vermeer's *Supper at Emmaus* had sold to a major Dutch museum for half a million guilders (the equivalent of tens of millions of dollars today) and had been called the finest Vermeer in existence. Van Meegeren was a multimillionaire and kept his money in coins in huge wooden chests.

But at the end of the Second World War, Van Meegeren found himself in a difficult and unusual situation. Because he'd sold art to the Nazis, he was arrested and charged with collaborating with the enemy. To avoid years in prison, he now had to prove his Vermeer was a fake and that he had deliberately tricked Goering, instead of collaborating with him. It was a hard thing to prove. At one point he was locked in a room and made to paint a "Vermeer" to show that he could. In the end the paint material itself became a key piece of evidence.

"Paint almost acts like blood at a crime scene," forgery hunter Philip Mould told the BBC in a program about the fraud. It is the pigments, and the different ways they've been used and made through the years, that give art authenticators their greatest forensic tools. And they have a difficult job: in some places, such as Russia, it is estimated that more than half of all artworks on the market are fakes.

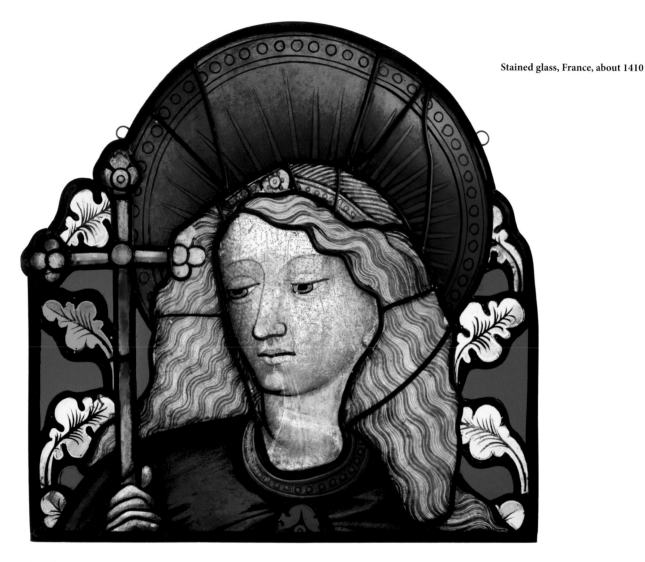

Stained glass, France, about 1410

The key piece of evidence for Van Meegeren was cobalt. The metal cobalt had been used for centuries as an ingredient in glass. It was used in medieval stained glass windows to make their astonishing blue. It was also an important glaze on porcelain. During the Ming dynasty (1368–1644), the Chinese imported cobalt from Persia and then used it to make blue-and-white porcelain that they exported right back to Persia again. In the 16th century, the blue-and-white craze spread to Europe and even to the east coast of Africa, where porcelain was shipped in by Chinese trading fleets.

Many of the most important Swahili coral stone houses had special niches carved into their main indoor wall, in which a single blue-and-white bowl would be displayed as a sign of sophistication and wealth.

Cobalt ink is invisible. But if you hold it over a fire, it turns green. When this was discovered in the 17th century, some people thought it was witchcraft and others used it for secret messages. A century later, it was used for trick furnishings on fire screens in pre-Revolutionary France. If you painted a winter landscape in ordinary ink, and then used invisible cobalt chloride to draw leaves

and vegetation on top of the bare trees, when you lit the fire, the cobalt would turn green and the landscape would appear to show summer. When the fire went cold, it would be winter again.

Eventually people figured out how to make cobalt into a blue pigment as well as a glaze—by roasting cobalt salts with alumina in a furnace. But that didn't happen until 1802. So when cobalt blue was found on the canvas Van Meegeren had sold to Goering, it was clear that Vermeer could not have painted it in the 1660s.

Using cobalt would have been a rare mistake for Van Meegeren, who, like just about every other forger in Europe, owned a well-thumbed copy of a 1928 PhD study by Dutch art expert A. M. de Wild. It not only gave a list of pigments and the dates they were used by artists but also revealed how experts recognized old paintings by their craquelure (cracking under the paint surface). It gave details of some key tests as well, including dipping a cotton swab in alcohol and rubbing it on the oil paint. If it's recent, the oil will dissolve.

When he had planned his forgeries in the 1930s, Van Meegeren had therefore done his best to make sure they were undetectable.

Glazed earthenware tile floor, Spain, about 1425–50

Glazed earthenware dish with a merchant ship, Italy, about 1510

He bought cheap 17th-century canvases and scraped off the top layer, so there was genuine craquelure underneath. Then he painted on top of that, using De Wild's list as a reference, and rolled up the finished canvas to create cracking on the surface. For the binder, instead of linseed oil, he ingeniously employed Bakelite, which dried into the hard, heat-resistant plastic used for telephones and radios and toys. Then he baked the painting in the oven so it would pass the cotton swab test.

Eventually, in 1947, Van Meegeren was acquitted of the serious charge of collaboration and sentenced just for forgery. And he owed some of his luck to another crook. He probably thought he had used genuine Afghan ultramarine on *The Woman Taken in Adultery*, but it turned out that the man who sold it to him had cut it with cheaper cobalt. Once that was discovered, the jury had no choice. They had to believe Van Meegeren's story.

Lead WHITE THE ENCHANTRESS

Pensive Woman on a Sofa (possibly Maria Gunning)
by Jean-Étienne Liotard, 1749

Eighteen-year-old Maria Gunning was such a celebrity when she arrived in London from Ireland that she needed a military escort to keep the crowds away during her daily walk in Hyde Park. Her shoemaker charged people sixpence just to see her shoes. She was from a well-connected but not particularly wealthy family, and she wasn't remarkably intelligent. Her fame came from

her astonishing, eye-catching beauty and nonchalant attitude. She and her three sisters were the "It girls" of their time.

Maria Gunning wore a great deal of makeup, spreading a cream made of lead white all over her face and then reddening her lips and cheeks. It was a fragile, slightly tantalizing look—lead gave women a waiflike appearance—and it was exceedingly popular in England's capital. In 1752, at 19, Maria married the sixth Earl of Coventry. He learned that the lead white was dangerous and tried to persuade her to give it up. There is a story that when she said no, he chased her around the dining table and wiped it off her face with his napkin. But still she wouldn't give up her toxic makeup. It eventually gave her blue lines all over her skin, cursed her with constipation, and made her go mad. And then it killed her. She died in 1760, aged just 27, hidden away in a corner of her stately home with only the light of a teakettle to see by. She was so upset about her ruined beauty that she didn't want anyone to look at her.

Maria Gunning's was just one of many deaths from makeup overdose. For centuries the dangers were ignored. Even as late as the 1870s, a U.S. cosmetics company, George W. Laird, was allowed to run a series of comic-strip advertisements in New York magazines. They showed a young man

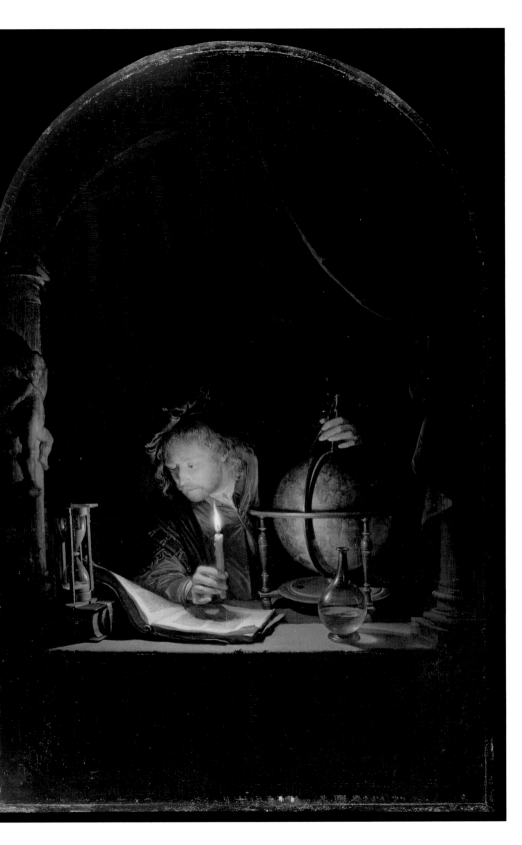

admiring a woman from a distance, and an older man agreeing she was lovely but was "45 years old, if she's a day." Her secret was Laird's Bloom of Youth makeup foundation, he said. The advertisement made thousands of women go out and buy it. But the main ingredient in Bloom of Youth was lead white, and it killed many women who used it.

The Roman historian Pliny warned in the first century that lead white was poisonous, as has just about anyone who's passed an opinion about it since. But the trouble was, particularly for artists, it was always the best white paint around. Beginning in ancient Greece, it was made by putting thin shavings of lead over a bowl of vinegar. The acid fumes would cause a chemical reaction and leave a deposit of white lead carbonate. In the 17th century, however, a radical new process was invented in Holland. It was called the "stack process" because it

Left: *Astronomer by Candlelight* by Gerrit Dou, late 1650s

Above: *Still Life with Lemons, Oranges, and a Pomegranate* by Jacob van Hulsdonck, about 1620–40

Left: *Pictura (An Allegory of Painting)* by Frans van Mieris the Elder, 1661
This work was painted on copper, which makes it seem to glow.

Above: *Burial of Atala* after Anne-Louis Girodet de Roucy-Trioson, after 1808

involved stacking one pot containing lead over another containing vinegar. But then workers would heap buckets of cow and horse manure—the new secret ingredient—over the pots. The room would be sealed. The manure would provide heat to evaporate the acid and carbon dioxide to transform lead acetate into basic lead carbonate. Three months later—and this cannot have been a nice job—workers would go in to get it. And in that time the gurgling excrement, sour wine, and poisonous metal would have worked their magic. Flakes of pure, lovely white would have formed on the gray lead.

It was one of the little miracles of the paint box. And artists loved it, because nothing else gave quite the same effect.

Take a look at all those 17th-century Dutch still lifes and portraits by masters such as Rembrandt van Rijn painted after this new stack process was launched. Do you see the gleam of light on them, that tiny smear that brings the whole object to life as if it is hit by sunlight in a dark room? The creamy gleam of the flame held by Gerrit Dou's astronomer, and the shine of light beneath it, and on the book? That is lead white—deadly, but beautiful.

Lead white was banned in the United States in 1977. Today artists mostly use titanium dioxide, a synthetic white made from a metal not discovered until the end of the 18th century even though it is the ninth most abundant element in the Earth's crust. It's a good white and a permanent one, although it doesn't have the wicked twinkle of lead. And of all the colors that aren't used anymore because they are unsafe, this ancient white is the one that artists today most often say they miss.

INDIGO GIRL POWER IN SOUTH CAROLINA

Eliza Lucas was another 18th-century teenager whose fate was linked to the story of colors, although, unlike Maria Gunning, she was a champion, not a victim.

Eliza Lucas was just 16 when her father went to fight against the Spanish Empire in 1739, leaving her in charge of the family farms in South Carolina. The year before she must have thought herself the luckiest girl she knew. She had arrived in Charles Town from boarding school in England to find it the liveliest town in the South, full of dancing and music and handsome young men. But now, with her mother ill, she had sole care of the 600-acre Wappoo estate, her little sister, and their 60 slaves. And it quickly became clear that the rice crop they had usually grown was not going to pay enough to support everyone. So her father, George Lucas, who had been posted to Antigua in the Caribbean, started sending seeds. First he sent alfalfa, and the next time he recommended Eliza try growing ginger. Neither crop did well, and it was only when he sent an envelope of indigo seeds that Eliza Lucas's fortune began to change.

"Indigo" is a curious word. Like "ultramarine," it didn't start by meaning a color at all. It just said where it historically came from—India. It was first traced in the Indus Valley more than 5,000 years ago, where it was called nila, meaning "dark blue." By the seventh century BC people in Mesopotamia, now Iraq, were carving recipes for making indigo dye onto clay tablets. In the

Indigofera by Georg Ehret, 1760

early 1500s the Portuguese found indigo growing in Goa, western India, and brought it back in the holds of their ships. It made a better blue than the old European woad, which was a fast grower but didn't have the dyeing strength. (Woad's name is the origin of the word "weed"; it is so rampant that it is banned in California, Utah, Washington, Oregon, and Montana.) However, the old-school woad dyers put up a good fight. In England the woad lobby managed to get indigo banned until 1660, saying it was poisonous.

By 1640 the French had started an indigo industry on their Caribbean islands, competing with the monopoly held by the English in India. The governor of the British East India Company called the French dye "deceitfull and counterfait," although what he really meant was that it was so good the English couldn't compete with it. India soon gave up its indigo trade and grew tea and opium and other crops instead.

The French might have kept their piece of the market longer, except that in 1745 they were at war with Britain. This forced the British Admiralty to find a new source for the nation's favorite blue, and Eliza Lucas got her little business going just in time to provide for their needs. It had taken a few years: her first crop was destroyed by frost, and the second season in 1741 was even more disastrous. George Lucas had sent a young man named Nicholas Cromwell over from Antigua to help his daughter learn how to ferment the leaves and make them into indigo cakes for export. But Cromwell had another plan. He could see that Eliza Lucas's success would compete with that of his own family plantation, so he deliberately spoiled the vat by throwing in too much lime as an alkali. At first she thought Cromwell was just incompetent, but when she realized the error was intentional, she fired him. The third crop was eaten by caterpillars but—and persistence is often a thread in the history of colors—the fourth crop was just right, and in 1744 Eliza Lucas produced South Carolina's first-ever indigo crop.

***Psyche at the Basketmakers*, designed by François Boucher, woven by
the Beauvais Tapestry Manufactory, about 1750**
 Indigo dye was used in the manufacture of luxurious tapestries.

Later this young woman made an unusual business decision. Instead of keeping her successful indigo-growing methods secret so she could corner the market, Eliza Lucas did the opposite. She gave seeds to all her neighbors and offered them advice. If she wanted to establish a market in South Carolina indigo and have enough to meet the needs of the British, she couldn't do it alone. Her gamble worked. By 1750, about 65 tons of indigo were exported to England from the Carolinas; five years later the total was nearly ten times that. The American colonies now had the market in blue.

But success didn't hold for long. When the British lost America in 1783 they were determined not to lose blue as well, so they set to making India's indigo production viable once more. Sadly, this was done by terrible exploitation of the workers. It even led to major riots in the 1860s. In 1917, the gentle India reformer Mahatma Gandhi's first act of civil disobedience was in support of the indigo peasants of northern Bihar.

The United States never stopped loving indigo blue. "Blue-collar" workers once wore indigo-dyed collars that showed less dirt than white collars. And indigo is the original dye of the pants patented in San Francisco in 1873 by two European immigrants. They were the first to reinforce pants with rivets, so the local men would have clothes strong enough for heavy work. They used a blue cloth made in New Hampshire that got its name from a town in the south of France: *de Nîmes*, meaning "of Nîmes," was shortened to "denim." The "waist overalls" they made would later be named after sailors' trousers from Genoa, shortened to "jeans." Their names were Jacob Davis and Levi Strauss, and their brand name got shortened to "Levi's."

Workers beating indigo liquid with wooden paddles in a British factory in Bihar, India, 1877, photograph by Oscar Mallitte

The 18th-century French *Encyclopedia* compiler Denis Diderot called these "devil's tanks" because they were so unpleasant to stand in.

Advertisement for Levi's from about 1899

The Most Mysterious Dye of All

Watching traditional indigo dyeing is a weird experience. The dyer puts fermented dark blue leaves in a vat with urine and some kind of alkali and stirs it gently, and the liquid turns yellowish green. Then in goes the yarn, and when it emerges a few minutes later it isn't blue, either, but a kind of sickly pale yellow. It's only as it hits the air that it begins to change color, as if by magic. When the British designer and craftsman William Morris learned the process in the 19th century, he told a friend in a letter, "It would be a week's talk to tell you all the anxieties and possibilities connected with this indigo subject."

So what is going on? Reduction is any chemical reaction that (slightly confusingly) involves the gaining of electrons. Oxidation is the opposite, and it involves removing electrons. By adding the urine and alkali, the dyer is effectively reducing the normally insoluble indigo into a form with extra electrons that is soluble in water and can penetrate the textile. This is called *leuco indigo*, from the Greek for "white." Then, when the *leuco indigo* meets the air, it oxidizes (meaning those extra electrons are removed again), making it turn back into insoluble blue indigo, which is now held within the fabric.

According to Jenny Balfour-Paul in her book *Indigo*, dyers in the Solomon Islands developed a way of chewing indigo leaves with lime from shells and then spitting the product onto bark cloth and working it in with their fingers as it turned from white to blue.

The Blue Boy by Thomas Gainsborough, around 1770
 When an X-ray (right) was taken of *The Blue Boy* in 1995, conservators had a surprise. Standing on the boy's left was a dog, almost certainly the Gainsborough family's own water spaniel Tristram. X-rays pass through most solid substances but are stopped by a few heavy materials, including lead. And since lead white was the main white for almost all artists at the time, an X-ray photograph is an excellent way to see some of the pentimenti (literally, "regrets") or mistakes that artists covered over while painting.

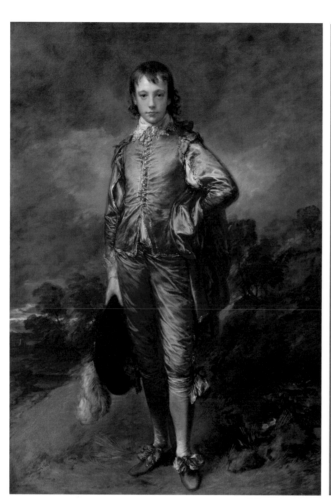

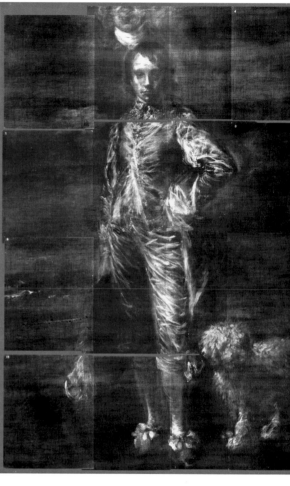

Gainsborough BLUE NEVER USE BLUE IN THE CENTER

Thomas Gainsborough was already one of the most famous portrait artists in England when in around 1770 he read that his rival, Joshua Reynolds, had said that a good artist could never use blue as the major field in the center of a painting. Reynolds thought it was too cold a color and should be used for shadows and distant things. He believed that if you put blue into the foreground, the effect

would be confusing and viewers wouldn't be clear about what was the front and what was the back. So Gainsborough took up the challenge. He picked up an old canvas and set up the easel on the second floor of his fashionable address at 17, The King's Circus, in Bath (his studio had good northern light from the windows overlooking the garden). And he experimented with blue.

For years the model for Gainsborough's painting *The Blue Boy* was thought to have been the son of a wealthy ironmonger from Covent Garden named Jonathan Buttall. But Jonathan was about 18 at the time it was painted, older than the Blue Boy seems to be, and it is now considered more likely that the artist got his 14- or 15-year-old nephew Gainsborough Dupont to dress up

in costume and help him out. Either way, the result is one of the most famous paintings from the 18th century. It appeared on prints and chocolate boxes throughout England, and when in 1921 the Duke of Westminster was forced to sell it to pay a tax bill, it was seen as a national tragedy. Before *The Blue Boy* left England to take its new place in the home of Mr. and Mrs. Henry E. Huntington of San Marino, California, it was cleaned and then exhibited at the National Gallery in London for three weeks. Ninety thousand people lined up to see it: the Blue Boy was like a celebrity.

Gainsborough had studied Anthony van Dyck's 17th-century portraits of King James I and the rest of the royal family to learn how he created the illusions of satin and shimmering fabrics that were so exciting to his sitters (and allowed him to charge huge fees). But according to curators at the Huntington Library, where *The Blue Boy* now hangs, the two used quite different techniques. Van Dyck applied his color in discrete patches, using short, consecutive strokes, while Gainsborough "presents a chaos of erratic color and handling." That fascinating satin on the Blue Boy's coat was made by applying the paint with vigorous slashes alternated with fine, detailed strokes, one over the other in layers. The technique created an iridescent effect.

The blue comes from many pigments, including ultramarine, cobalt, slate, turquoise, charcoal—and indigo. And in 1770, with most of England's indigo coming from Carolina plantations, it is likely that the little cake of indigo Gainsborough used came from the American colonies, and quite possibly from the very plantation in South Carolina run by Eliza Lucas Pinckney right up until she died in 1793.

Why Is Indigo in the Rainbow?

Schoolchildren in the United States remember Mr. Roy G. Biv. Pupils in India reverse it as VIBGYOR. In England children say "Richard of York gave Battle in Vain" after the Battle of Wakefield in 1460. But if not for the plague, there might have been six colors in the rainbow, and none of these mnemonics for Red-Orange-Yellow-Green-Blue-Indigo-Violet would work.

In 1665 the plague arrived in London, and about 100,000 people died. London was closed to traffic, all fairs and carnivals were canceled, and both English universities were shut. One of the students sent home was the Cambridge postgraduate Isaac Newton, who, like many students with nothing to do, spent a lot of time in his room—except that *his* room became the center of the expansion of human knowledge.

Through experiments with things he found around him, Newton began to understand the world as a place with absolute physical laws. He watched an apple drop in the garden and worked out a law of gravity. And he found two toy prisms bought at a fair and started to play with them. Everyone knew that putting a prism in front of light would make a "colored image of the sun" against the wall. But—and this was Newton's genius—when he put the

second prism upside down so the multicolored light passed through it, the colors turned back into ordinary white light. Newton concluded that white light was made of all the colors in the rainbow. Thirty-eight years later he would publish his theory in "Opticks." It was the first full explanation of how colored light is made of rays that bend at different angles when they pass through a prism and how the angles are consistent. So red (the longest wavelength we can see) always bends least, and violet (the shortest wavelength) always bends most. And while Newton was writing about red and violet, he named five colors between them: orange, yellow, green, blue, and indigo.

But isn't "indigo" another word for "blue"? Like many people of the era, Newton had a mystical belief in the number seven. The musical scale had seven notes, there were seven planets, and Newton decided that the rainbow should have seven colors. Also, most of the light from our Sun is green; it's the strongest light. And it's in the middle of the spectrum, so Newton wanted the same number of colors above green and below. For the seventh color, he could perhaps have chosen turquoise, between green and blue. But instead he chose the name of the new blue dye that had danced in from the Indies.

ROSE MADAME POMPADOUR'S LUXURIOUS PINK

When in the 1690s Europe was devastated by a war between France and its neighbors, many aristocrats on both sides gave up their silver plates and platters for the war effort. But when peace came at last, in 1697, there was a problem: what on earth would the rich people eat from now? Unpainted stoneware, made from clay, was what the poor used, so that was no good. But Chinese porcelain, the obvious replacement, was so mind-bogglingly expensive it was known as "white gold," and even the aristocrats couldn't afford much of it. Suddenly the desire to know the secret of making it became a matter of urgency.

The Saxons (in what is now Germany) got there first. An alchemist named Johann Friedrich Böttger had been locked up in King Augustus the Strong's castle in Dresden for years to work on making gold from ordinary metals. Prison conditions had been mostly pretty good: he had been able to walk in the gardens and entertain on silver platters. But then in 1705 Böttger was moved to the rundown castle of Meissen,

The Alchemist by Cornelis Bega, 1663

The Word "Pink"

"Pink" once meant "yellow." Dutch "pink" was a yellow lake prepared from Persian berries or American oak. A "pink" also means a "frilled edge." Scissors that cut zigzags are pinking shears. But in the 16th century the popular dianthus flowers, similar to carnations, became known as "pinks" because of their notched petals. They happen to be mostly a pale red, what we, today, call "pink."

with windows bricked up, horrible food, and 24 hot furnaces so he could experiment on samples of earth shipped from all corners of the kingdom. Augustus made things deliberately horrid. He wanted Böttger to be desperate to discover the secret of making beautiful white porcelain. And in around 1707 he did. It involved a white clay called "kaolin," which conveniently had just been discovered 80 miles down the road, in Schneeberg. Carefully packed crates of "Meissenware" were soon being dispatched to castles and palaces all over Europe, mostly transported along waterways to reduce breakage. The recipe, needless to say, was a state secret.

At first the porcelain was all white, to match the color Europeans thought was so dear to the ancient Greeks. Then in 1720 the Meissen factory mastered an underglaze blue in imitation of the Chinese blue-and-white, and then successively other colors as well as gilding in gold leaf,

which was particularly tricky. The Meissen manufacturers often copied designs from Japanese and Chinese porcelain, which were all the rage in Europe, known as japonaiserie and chinoiserie. These new colors also meant that the superrich who could afford the early versions would still be coming back a few years later to buy the latest fashions. It seemed there was no end to the profits.

The French found Meissen's success pretty depressing. An alarming proportion of the national wealth was going east to Saxony to pay for plates and teacups. So, in 1740, French entrepreneurs, backed by the brother of the minister of finance, set up their own porcelain factory in a disused horse-riding school at the royal Château de Vincennes. It was so close to Paris that today you can get there by Metro. They didn't yet know the secret of porcelain, although they had a lot of industrial spies on the case (in China and in Meissen, which was rumored to have spies

A Fox with a Chicken by the Meissen Porcelain Manufactory, model by Johann Gottlieb Kirchner, 1732

In 1732 Augustus the Strong asked the Meissen Porcelain Manufactory to make him a menagerie of porcelain animals "in their natural sizes and colors." This is one of them. But why is it white and cracked? The trouble is, every firing causes stress on the clay, and with a piece this big (this fox is 18 inches high) there are going to be cracks. A final firing with enamel colors failed every time. The factory artisans eventually painted the animals with oil paints. But the colors discolored and flaked and were later removed, although if you look carefully there are still traces of reddish-brown paint inside this fox's ears. If you ever see large-scale glazed china vases or figures made hundreds of years ago, it's good to remember they are wonders of engineering and that to finally make them would have taken many, many failures.

Ewer by the Sèvres Manufactory, 1757

Still Life: Tea Set by Jean-Étienne Liotard, about 1781–83

in every coffee shop). But they did know an old technique adapted from the Persians to coat delicate stoneware with a white glaze to pretend it was Chinese porcelain. For the moment that would have to do.

The ingredients were soap, glue, frit (which is a semitranslucent glass), and marl (which is a white mixture of clay and chalk). You could scratch it with a knife, so it was called "soft-paste" porcelain, as opposed to the better Chinese (and German) "hard-paste."

In the beginning the Vincennes manufacturers couldn't figure out how to get gold to stick to the porcelain. But in 1748 a Benedictine monk, Hippolyte Le Faure, arrived at the factory gates with a secret recipe for a gold mordant, containing garlic. He sold it for 3,000 livres (nearly three years' salary for a skilled painter at the factory).

After 1745 the Vincennes factory had a major celebrity backer. King Louis XV had married when he was 15, but his wife, after having 10 children and almost dying with the last one, said she was finished with him. Louis turned to mistresses, including the glamorous Madame de Pompadour.

Whatever Madame de Pompadour wore and did one month, half the wealthy women in France would wear and do the next. So in an early form of celebrity marketing, the factory would give her their latest models of porcelain, and in exchange she would hold them, drink from them (tea was very fashionable), or simply talk about them. One year she gave the king a surprise birthday party and decorated her house from floor to ceiling with colored porcelain flowers from Vincennes, with the rooms filled with scents to match.

The colors created at Vincennes reflected a balance between Madame de Pompadour's taste and what was technically possible. Madame de Pompadour loved colors, and after 1745 the porcelain-makers started experimenting with colored backgrounds. The earliest was yellow, from a mixture of tin and antimony, but later sky blue, green, violet, and crimson had their brief moments of celebrity.

The most famous color was none of these. It was a rich bright pink introduced in 1757 after the factory had moved to Sèvres to be closer to the royal palace at Versailles. In France it was known as *rose* or *roze* and was rumored to be such a favorite of Madame Pompadour (then retired as the king's mistress but still a fashion icon) that in England it became known as "rose Pompadour" or "Pompadour pink."

The glaze had a strange history. To the Europeans it looked Chinese. To the Chinese it was European. It was based on the secret of a 17th-century glassmaker in Potsdam and involved mixing glass with flecks of gold dissolved in nitrohydrochloric acid, known as *aqua regia*, or "royal water," because it can corrode even noble metals like gold and platinum. Gold plus glass made a rich ruby red. When Jesuit missionaries took the recipe to China in the late 17th century, the Chinese called it *yangcai* (foreign color). Later they exported it back to Europe in pretty combinations with greens and other soft pastels. It became known as *famille rose*, or "pink family," and was seen as delightfully oriental. At Sèvres the color was used in combinations that today seem extraordinary. An eye-popping mixture of rose and green porcelain burst into fashion in 1759 and had all but disappeared in 1761, only to be replaced by rose in combination with *beau bleu,* or

"beautiful blue," which is almost as startling.

Porcelain from Meissen, Vincennes, and Sèvres came at a time of conspicuous consumption, when the things you owned began to define who you were. Not since Roman times had so much luxury been so prized. It is easy to look at these objects today and understand why, when the millions of people starving in France saw their ruling classes spending so much money on such fripperies, they were inspired to start a revolution in 1789.

Lidded potpourri vase by the Sèvres Manufactory, about 1760
The world was a stinky place in the 18th century. There were no public sewer systems, and people used chamber pots, which they kept under their beds or in the wardrobes so the urine fumes could drive away the moths. This meant that there was a huge demand for perfumes and other ways of making the houses of rich people smell nicer. This potpourri vase was one of the most difficult things the Sèvres factory ever made; it was a triumph of pottery engineering. The lid has holes to release the scent of dried flowers slowly, to make a room more fragrant. But the piercing weakened the structure, and this type of pot (nearly 15 inches high) tended to collapse in the kiln. Only a dozen were successfully produced.

LIGHT AND THE AGE OF ENLIGHTENMENT

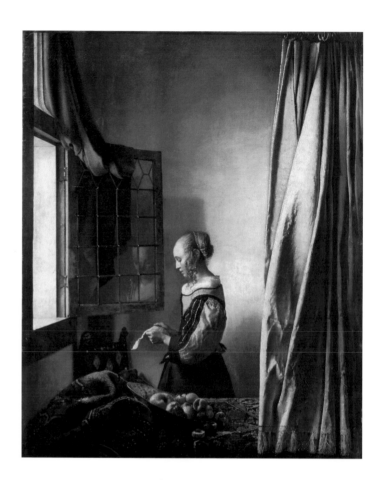

Girl Reading a Letter at an Open Window by Johannes Vermeer, about 1659

The period from the end of the 17th century to the beginning of the 19th is often called the Age of Enlightenment, mostly in the metaphorical sense, because people began to have a clearer scientific understanding of the physical world. New fields of inquiry would eventually lead to understanding radio waves and electricity and color and chemistry and so many other things that are important to our lives today. But, also, the light actually changed.

Until the 1600s, window glass in houses was expensive. If you could even afford it, it would be installed in small, greenish panes with impurities, so the light would scatter as it came into the room. Plate glass, as we know it, wasn't invented until the 20th century, but by the end of the 17th century people had learned how to make window glass bigger and less knobbly. (At the same time glass mirrors were introduced into more ordinary houses, bringing new kinds of light and reflection.) The new windows had small, almost clear panes—perhaps 32 to a sash window (16 over 16). Later the technology had improved so you could have just 12 panes in windows (6 over 6). And when in 1739 the French portrait artist Maurice-Quentin de La Tour produced a life-size portrait of one of the fabulously wealthy heirs to the de Rieux finance fortune, it was seen as a wonder, and not just for how he had depicted his subject so realistically using chalk crayons, known as "pastels." Because pastel paintings are fragile

and have to be protected by glass, the life-size portrait—at 6 x 5 feet, the largest pastel painting ever made—required the largest piece of glass possible. People had never seen anything like it: it was a triumph of technology.

Artists' studios became lighter places, too. With more windows, better candles, and electricity about to arrive (in 1881 the Savoy Theatre in London was the first public building to be lit by electricity), artists were able to think in new ways about light, and how it plays on objects, and how they could make paintings to express this new experience.

The Cat at the Window by Jean-François Millet, about 1857–58

Titian Blue
SIMPLY UNBELIEVABLE

Pigment scoops, Winsor and Newton

In 1795 a young artist, Ann Provis, and her father, Thomas Provis, paid a visit to Benjamin West, the American-born president of the Royal Academy of Arts in London. He was a friend of Benjamin Franklin and painter to King George III. And he had no idea he was meeting two of the cleverest con artists in the history of color. They claimed to have a copy of a 200-year-old Italian manuscript with the key to how Venetian artists in the Renaissance applied their paints. They said the original had been discovered in Italy by Ann Provis's great-grandfather and that Thomas Provis had copied it out by hand shortly before it was destroyed in a fire.

The Provises had researched their victim. It was common knowledge that West had gone to Italy and fallen in love with the works of the great masters: he had even named his son Raphael. And it was also well known that he was frustrated at how his best attempts to copy their paintings had failed. He often visited Titian's *Bacchus and Ariadne* at the National Gallery in London, admiring how the whole painting "from the beginning was worked with colors." He (like the rest of the artists in London) just couldn't figure out how to get that elusive luminosity, or light, that almost seemed projected from the bottom-most layers of the canvas.

The rule for a successful con is simple: You find someone who wants something for nothing and you give him or her nothing in exchange for something. West wanted

to believe that the manuscript could teach him to paint like Titian. He allowed Ann Provis to help him with a painting that he later claimed to be his own work. And then the Provises blackmailed him. They threatened to tell the world that he'd stolen their "discovery." To avoid scandal, West agreed to lend his name to a syndicate in which other artists paid high prices for the "Venetian Secret." When the fraud was uncovered two years later, the Provises were richer by at least 600 guineas (equivalent to about a million dollars today).

So what was it that made well-respected men risk their reputations to learn how the Italian masters used color? Studio practices had changed. Artists didn't usually start as apprentices at the age of 10, as Titian had. They rarely learned to blend their own pigments, as every artist in history had done until the end of the 1600s. Instead, in this newly industrializing society, they bought oil paints from "colormen" who stored them

in jars and sold them by weight. The artists had paints similar to those used during the Renaissance, but they didn't understand them and were making mistakes using them.

The Venetian Secret seemed too good to be true, and it was. It has partly been lost (it was eked out in little hints and chapters, to keep the victims begging for more). But we know it had three main elements. The first was a dark red ground, painted directly onto the canvas after it had been sized, or treated with rabbit-skin glue. The second was thinned linseed oil as a binding medium. And the third was what the Provises called "Titian blue": mixing ivory black with Prussian, Hungarian, or Antwerp blue, and using that as a middle base on which brighter pigments such as vermilion, verdigris, and ultramarine were painted as semitransparent glazes. West and the other duped artists should have run a mile as soon as they heard this last bit—because Prussian blue was not invented until 1703, more than 120 years after Titian's death.

Indian YELLOW TURNER, COWS, AND MANGOES

Watercolor paint box, England, about 1780–1800

A number of artists rejected the Venetian Secret from the beginning, and one was Joseph Mallord William Turner. He was a phenomenon: eccentric, irascible, mysterious, mean with money, and a force of nature. He was fascinated by the effects of color and atmosphere, and he really wanted to experience them close-up. Once his ship was caught in a storm leaving the port of Harwich. While other passengers cringed below, he requested to be lashed to the mast. He stayed there for four wretched hours, and when he had thawed out, he sketched all he had seen. He later said, "I did not expect to escape, but I felt bound to record it if I did."

If Turner had taken part in the *disegno* vs. *colorito* debate, he would certainly have come down on the side of *colorito*. And it wasn't just that he used outrageous combinations of hues and shades to create storms and fires. It was his attitude. Sometimes he would submit his canvas for the annual Royal Academy show so late that he would go down there on varnishing day, when other artists were touching up the final details, and he would paint almost the whole thing, right there, in front of everyone. He would use a palette knife and his fingers, scarcely touching a brush. And it would be brilliant. It was immensely annoying for the other artists, and it was certainly intended to be. Turner was a showman.

When historians are studying at what point certain paints were introduced in the 19th century, they often look at Turner's paintings because they know he would have tried out new paints as soon as he could get them. Cobalt blue, iodine scarlet, chromium yellow—he used all the modern chemical colors the moment they were available. Sometimes his experiments worked out, and sometimes they didn't. His colorman, William Winsor (of Winsor and Newton), would despair. He'd tell Turner that some of the pigments he was buying were not going to last, but the artist wouldn't listen. According to Joyce Townsend, senior

conservation scientist at Tate Britain, "Turner told him to mind his own business. He didn't care."

Turner was a master of fast-action oil painting. But there was another, less fashionable but faster, medium that suited his interest in changeable weather. Watercolors are pigments mixed with water-soluble gum, usually a version of the gum arabic that had been so loved by the Egyptians. Watercolors had been around for centuries, but for most of that time they were tricky to use: you

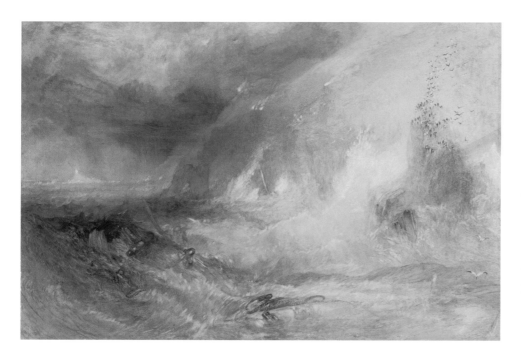

what the name does not mention is that it was made from the urine of cows or buffalo fed mango leaves. They were left to roam in mango orchards near Monghyr in Bihar (India's poorest state, north of Kolkata), and then they would be made to urinate into buckets. The result was added to clay and rolled into crumbly, round shapes the size of Ping-Pong balls. When you needed to paint you would grind the color ball and bind the powder with acacia gum. It was a strong, transparent, fluorescent yellow, and when in the 1910s production stopped because it was cruel, many artists were sad to see that luminous paint disappear.

Long Ship's Lighthouse, Land's End by Joseph Mallord William Turner, about 1834–35
This watercolor was painted in 1834, just after the invention of watercolor paints that could be used straight from the pan.

bought them in dry lumps and then had to grate them like parmesan.

In 1766 a colorman's apprentice, William Reeves, discovered that if you mix honey with the pigment and gum arabic, the paints don't dry out. Then, in 1832, Winsor (a chemist) and Henry Newton (an artist) thought to add glycerin, which meant it was possible to dab the paints straight from the pan as we do today. Suddenly artists could paint outside more easily. Needless to say, Turner was one of the first to use the new "pan paints." He'd go out in all weather, and he usually carried an umbrella with a sword hidden inside, just in case he met ruffians on the way.

One of the traditional colors Turner had in his watercolor box was Indian yellow. It was yellow and it came from India, but

Modern Rome—Campo Vaccino by Joseph Mallord William Turner, 1839
Turner's color scheme was so unusual, with its bright whites and new cadmium yellows, that one critic suggested he had "yellow fever."

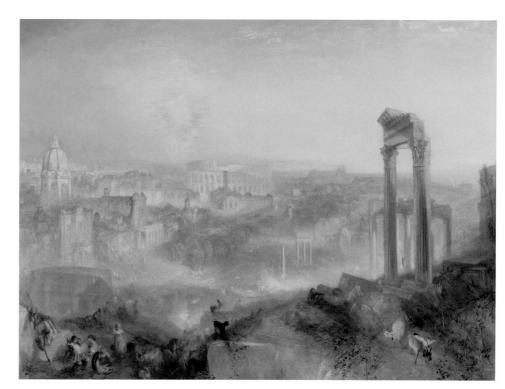

Madder RED INVENTING THE COLOR WHEEL

Color wheel, Plate 3 from *On Colors and Their Applications to the Industrial Arts with the Aid of Color Wheels* by Michel Eugène Chevreul and René Digeon, 1864

In around 1820 the Royal Tapestry Manufactory at Les Gobelins in Paris had a problem. The factory, set up in 1663 to make gorgeous wall coverings for the palaces of the Sun King, Louis XIV, was famous for its reds. In fact, the dyer after whom the whole area was named, Jehan Gobelin, had made his fortune from the astonishing brightness of his scarlet cloth. But now the reds and other bright colors in the royal tapestries were coming up dull, and there was seemingly nothing anybody could do about it. So Les Gobelins brought in a leading chemist, Michel Eugène Chevreul,

and made him the director of the factory, to see whether he could get to the bottom of it.

Gobelins tapestries could be gigantic, more than 12 feet high and 16 feet across. Making them was incredibly expensive, involving large teams of artists, dyers, spinners, weavers, and apprentices. And even then it could take years to make a single one. So imagine you are one of several weavers who have been sitting in this one place for a year to make a tapestry that is half finished and already 6 feet high. And now the color looks slightly weird.

This was the problem Chevreul had been brought in to sort out. He noticed that when his weavers put certain colors next to other colors they seemed to change. Madder red next to orange looked duller than the same madder red next to purple. And blacks seemed so different when they were next to blues rather than yellows or reds that clients were complaining that the dyes were off. And yet the weavers knew they had used threads from the exact same dye batches. What was going wrong?

Red, and the extraordinary hot pinks and oranges you can see in early Gobelins tapestries, were from a blend of cochineal and the pink root of a shrub from Turkey and the Middle East called "madder." In the 18th century Europeans were obsessed with uncovering a secret Turkish recipe for making madder into a rich red dye. The Dutch got the recipe first in around 1730, and when the French eventually learned it

17 years later it wasn't great news for the residents near Les Gobelins. The Turkish secret involved applying alum, tin, and tannin—all normal for dye-making. But there was also calcium, which the French scientists had guessed after seeing what happened to the skeletons of pigeons that had eaten madder dust. And (and here is the unexpected, even shocking bit, which they hadn't guessed) the secret recipe involved adding ox blood and cow or sheep dung to threads that had been steeped in rancid castor oil. It was probably the most complicated dyeing process ever invented. It's hard to know which bit of the process smelled worse. Stale blood? Cow manure? My money's on the rancid oil. But it did make a lovely red.

So why did this lovely red suddenly look terrible? Chevreul dedicated many years to finding out. First he did the obvious things and tested the raw materials, visiting their sources, seeing if the batches were spoiled. But nothing seemed to be wrong. Then he realized that the problem was not in the materials at all. It was in the color combinations.

Chevreul demonstrated that every color has its own complementary color: for yellow it's violet, for orange it's blue, for red it's green. The contrast between complementary colors is what makes them seem to pop, or stand out, in a composition. (If I am asked my favorite color, I think of an orange in front of a bright blue summer morning sky.)

Sancho's Entry on the Isle of Barataria, from *The Story of Don Quixote* series, woven at the Gobelins Manufactory, 1772

See the picture here of a trick being played on Sancho Panza (the companion of Don Quixote in the classic tale by Miguel de Cervantes) when a group of noblemen pretended he had been appointed governor of the fictitious island of Barataria and then laughed at him as he acted out the role. Draw an imaginary line across the whole tapestry, and imagine you're the weaver, having to pick up a new thread and loop in the old one each time you come to a different shade. Then move up a thread and start along the line again. It would take an expert weaver a year to do a square yard. Usually, in a large tapestry manufactory like the Gobelins, several weavers worked side by side to complete a piece. It could take a team one or two years, or even longer, to finish a single tapestry.

Gobelins workers employed at the low-warp loom, 1771

The yellow orange is complemented by the blue, from *The Harmony of Colors* by Édouard Guichard, 1880

But it's more complicated than that: orange mixed with black (to make it darker) has a complementary color of blue mixed with the same amount of black; a pale orange is complementary with a similarly pale blue. So in Chevreul's groundbreaking 1839 book, *The Laws of Contrast of Color*, he created not just one color wheel but 21. He divided his wheels into "hot colors" (those that act assertively, such as orange, red, and yellow) and "cool colors" (those that tend to recede, such as blue, green, and purple).

Chevruel also found that if you put two colors next to each other, the edge where they touch seems to have a slightly brighter tone. Painters might have put that down to the blending of pigments, but Chevreul, with his experience in the tapestry studios, and his experiments with twisting colored

threads around each other, realized that what he was seeing was an optical illusion. Tapestries, unlike paintings, never have blended or layered colors; each little connection between the vertical warp and the horizontal weft is a pure drop of dyed thread. And Chevreul was able to show that placing two separate pure colors close to each other produces the same effect on the eye as mixing paints on a palette. This idea would later be picked up by the Pointillist (or "dotty") movement of painters at the end of the 19th century, led by the French artist Georges Seurat, who made paintings with little dabs of pure color.

Next, Chevreul looked at what happens when you put lighter strips of a single hue next to each other. He called it the "simultaneous contrast of gradated tones."

The Banks of the Marne at Dawn by Albert Dubois-Pillet, about 1888
Dubois-Pillet used the Pointillist technique: painting with dots of pure color and leaving the viewer's eyes and brain to do the job of blending them into a picture.

To a Summer's Day by Bridget Riley, 1980
British "Op" artist Bridget Riley is known for the optical illusions she creates through stripes of colored acrylic paints. Since the 1960s she has been fascinated by what she calls the "innate character of color when set free from any sort of task of depicting or describing things." *To a Summer's Day* is more than 9 feet long. When you look at it close-up you can see how curved yellow and blue stripes are intertwined with violet and rose ones. From farther away it looks as if there are some green and brown stripes as well, and the overall effect is as if something underneath the surface of the canvas is actually moving. Riley is playing with some of the color effects that Chevreul struggled to understand a century and a half earlier.

The edges seem to be emphasized, giving the thing a fluted look. If you don't want that as an effect, then Chevreul worked out how you need to paint or weave the edges of the darker tones in slightly lighter colors, to give the sense of a gradation.

Chevreul's research led to a theory that would revolutionize the use of color in European art and would explain something that artists had been noticing for years but had rarely articulated. For the first time artists were confronted with ideas about the active role of the brain in the formation of colors—and how colors are just effects, created in the world inside our heads.

Graphite PENCIL LEAD IS NOT LEAD

There's a joke about NASA scientists in the 1960s spending millions on a pen that could write in space. "What do you guys use?" they asked their Soviet counterparts after proudly showing off their invention. "We have the pencil," was the answer.

When Jean-Pierre Alibert died in Paris in 1905 at the age of 85 he was hailed as a hero. His hometown wanted to name a street after him. He was an adventurer who had given huge sums of money to good causes. You might not have heard of him today, but Alibert made once-rare pencils into commonplace items. It all happened because he went looking for gold in the wrong place.

The first thing to know is that "pencil lead" is not made of lead. If it were, it would have been banned long ago and there would be horror stories about children who got sick from chewing their pencils in boring classes. Pencils are made from what, since the late 18th century, we have called "graphite," from the Greek word for writing, although

it used to be called "blacklead," or *plumbago*. Graphite, like diamond, is a form of carbon, but instead of being the hardest mineral on Earth it is one of the softest. It is so soft that when you rub it against an even surface, the layers slide off and stay where they're put.

The second thing to know is that before pencils were cheap, most artists did their preparatory drawings with chalk, charcoal, or ink made of oak galls or soot, or with what was called "silverpoint," which involved painting with a silver tip onto a slightly uneven white surface so the tarnish on the silver was left behind. Real lead was occasionally used, but it was only really good for ruling lines, so engineers and architects liked it more than artists did.

And the third thing to know is that graphite's first use was not for pencils but for making weapons. Before you bake a cake you have to butter the pan so the cake will slide out without breaking; when you were making cannonballs 400 or 500 years ago you needed the iron to slide out of the mold. Graphite was the butter. The best graphite in the world was discovered in the English Lake District in 1564, the year of Shakespeare's birth, when Queen Elizabeth I's armies were casting cannonballs like crazy for the wars against Spain. That graphite was so valuable it was guarded by armed militia. Miners caught taking it out were flogged, and they were strip-searched after every shift.

Later on, some of the graphite from the Lake District did make its way to artists' studios, where it would be wrapped with string or sheepskin (and later in a hollow stick of soft wood). This pure material made satisfyingly dark marks and could also be erased with breadcrumbs, so you didn't have to get the picture right the first time.

Pencils were good for industry and accounting and engineering and inventions and so many things as well as art. So they were important. In the mid-1790s France was at war with most of the rest of continental Europe and things were cooling with Britain, just before the Napoleonic Wars. A small but irritating consequence for France was that there were no pencils available anywhere. Something had to be done. One of Napoleon Bonaparte's

A Winter Scene with Two Gentlemen Playing Colf by Hendrick Avercamp, about 1615–20

favorite officers was Nicolas-Jacques Conté. He'd been a portrait painter and inventor before he became a soldier. (Later he'd be put in charge of the balloon corps in the Egyptian expedition and would accidentally set a hot air balloon on fire in front of a huge Egyptian crowd, who fled, thinking they were seeing a terrible weapon being unleashed.) Napoleon asked Conté to solve the problem of the pencil supply, and in just eight days Conté invented a way of mixing clay and powdered low-grade French graphite to make different grades of drawing pencil, from hard to soft. Conté's system of grading is still used in Europe,

with the blackest pencils 9B (very soft, good for deep shading), the hardest 9H (good for architectural use), and HB (in the United States, number 2), the very middle grade and still the most popular for sketching and writing.

In 1847, standing behind a cold river in the eastern reaches of Siberia, a gold-pan in his hand, Jean-Pierre Alibert would have known about Conté's pencils from 50 years before: it was part of the history of Revolutionary France. He certainly knew enough to recognize the shiny mineral he was looking at. And he also knew enough to know that although it was not gold, it was as

good a quality graphite as had just run out in England Lake District mines.

Alibert had studied business in England and had started a fur auction in St. Petersburg, Russia. It's not surprising that, on finding a new source for a rare mineral, someone like him might have wanted a bit of the action. But where his story becomes astonishing is that the place where he saw the graphite in his pan wasn't its source. It was nowhere near. So he put an expedition together, and they followed that river back 100 miles, and then 200 miles, and the territory was so remote and cold it was known as the Ice Desert. But Alibert kept urging the

Horses and Riders by Théodore Géricault, 1813–14

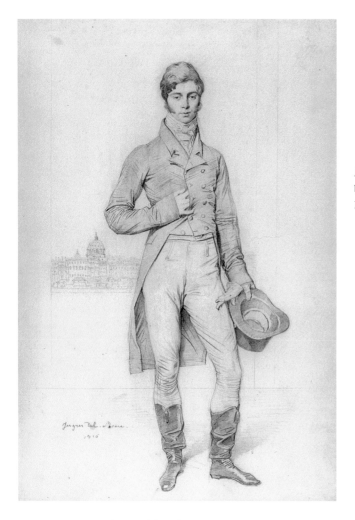

Portrait of Lord Grantham
by Jean-Auguste-Dominique
Ingres, 1816

Why Are Diamonds and Graphite So Different If They Are Both Made of the Same Stuff?

On the Mohs scale of hardness from 0 to 10, diamond is 10, and graphite is less than 1. Yet they are both pure carbon. The difference is the structure. In diamonds, which were formed at tremendous heat and pressure miles underneath Earth's crust, each carbon atom is bound to four other carbon atoms (making a substance so tough you can't cut it, except with other diamonds). But graphite is less complex. Each carbon atom is bonded to just three others (leaving free electrons hanging around and making graphite into a semiconductor, while diamond does not conduct). The difference means that graphite just holds together in two dimensions, and the layers slide over each other and tend to stay behind on any slightly bumpy surface like paper. Touching a lump of graphite feels like holding soap. The Soviet writer and political prisoner, Varlam Shalamov, who was sent to forced labor in a Siberian graphite mine, had many hours to reflect on the material. "Graphite is carbon that has been subject to enormous pressure for millions of years," he wrote later. "It might have become coal or diamonds. Instead, it has become something more precious, a pencil that can record all it has seen."

expedition on, and several hundred miles inland from his first sighting, close to the Chinese border, he at last found the place where the graphite had come from. He built a settlement there (he called it Alibertsburg), and later he made an exclusive deal with the U.S. company A. W. Faber, which shipped some of the pencils back to Europe.

And so, for about 50 years, most of the world's best pencils were made from rare Siberian carbon, carried across icy mountain terrain on the backs of reindeer. And it, and Conte's recipe, contributed to creating the art of the 19th and 20th centuries. The Impressionist Paul Cézanne used a pencil to sketch his famous bathers. The French-born émigré Jean-Jacques Audubon sketched many of his famous bird paintings with pencils. Jean-Auguste-Dominique Ingres, when he was a struggling young artist in Rome, earned his living by drawing portraits in graphite of wealthy vacationers.

The Prussian chancellor Otto von Bismarck famously used a pencil to tamp down his pipe. And although the source of the graphite has changed, the wood is still cedar: some 60,000 trees are felled annually, from Florida to China, to produce wood products including the 15 billion or so pencils per year the world demands—two for each living person.

Mummy BROWN FUNERAL FOR PHARAOHS

It was a small funeral, but very select. There was just a boy, who was to become a very famous writer, and his uncle, who was already a very famous artist; and nobody had actually met the deceased, or not in the usual sense of the word.

In his autobiography, *Something of Myself*, the British author Rudyard Kipling described how when he was young he used to spend Christmases with his Aunt Georgie and his Uncle Edward, who to most people was better known as the Pre-Raphaelite painter Sir Edward Burne-Jones. "Pre-Raphaelites" had named themselves because they didn't like what had happened to painting in the 19th century, and they longed to return, with their colors and their shading, to the time of the great medieval artists, before Raphael (and Titian and Leonardo and Michelangelo) had, in

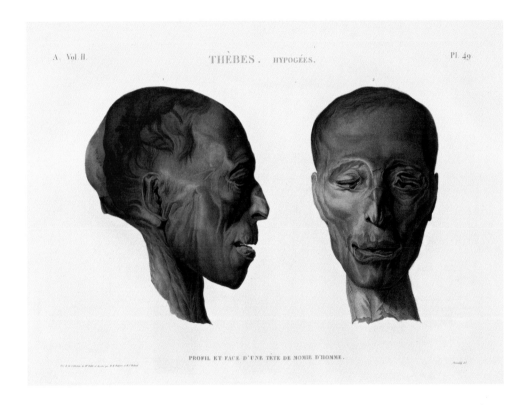

Mummified heads from Thebes in Egypt. From *Description de l'Égypte* by Antoine Maxime Monsaldy, 1812

Buried for Ages, Colonnaded Terraces of Queen Makere's Temple, Der-el-Bahri, Thebes, Egypt by Underwood & Underwood, 1904

their eyes, messed it up. The Burne-Jones family home, in Fulham, west London, was a paradise, full of "smells of paints and turpentine whiffing down from the big studio on the first floor" and "pictures finished or half finished of lovely colors." One day in around 1875, when Kipling was about 10, they had a visit from the artist Lawrence Alma-Tadema and his family. Kipling remembered how his uncle "descended in broad daylight with a tube of 'Mummy Brown' in his hand, saying that he had discovered it was made of dead Pharaohs and we must bury it accordingly. So we all went out and helped . . . and to this day I could drive a spade within a foot of where that tube lies."

Who would have thought to pick up a bit of the dead body of someone who lived perhaps 3,000 or 4,000 years ago, now crumbly and dark between the folds of ancient wrappings, and make it into paint? Actually, mummy was first used as a medicinal substance as early as 1300, which is even more bizarre. Virtually all the pigments that were known to painters from the Middles Ages to the Renaissance were also medicines, including lead white, minium, vermilion, chalk, orpiment, sepia, ultramarine. . . and mummy. These medicines were supplied by apothecaries, who were also one of the main sources of supplies for painters. No doubt an artist somewhere saw mummy in his local apothecary shop and thought, "I wonder if this would make a good bit of paint?"

By 1712 an artist supply shop had opened in Paris called À la Momie (To the Mummy), and in 1797 a *Compendium of Colors* published in London proclaimed that the finest brown used as a glaze by Benjamin West, president of the Royal Academy, "is the flesh of mummy, the most fleshy are the best parts." In 1809 British colorman George Field got a delivery of mummy from 21-year-old Henry Beechey (son of the artist Sir William Beechey), who was working as secretary to the British consul general in Egypt. The package arrived "in a mass, containing and permeating rib-bone etc.—of a strong smell resembling Garlic and Ammonia." Of the paint, it "grinds easily—works rather pasty," Field wrote. It made a thick, dark paint rather like bitumen, good for shading and no good in watercolor.

Mummy brown was a common shade in artists' colors until 1925, but it cannot be bought from any paint shop today. In 1964 *Time* magazine reported that London colormaker C. Roberson, which for a while had been the only distributor, had run out a few years before. "We might have a few odd limbs lying around somewhere," managing director Geoffrey Roberson-Park told *Time*, "but not enough to make any more paint."

When he buried his tubes of mummy brown in the 1870s, Edward Burne-Jones did not have to worry about reducing the number of paints he had to choose from. A new movement had already begun that would mean that instead of having just a few dozen colors, artists were about to have hundreds, even thousands. It started with a teenager doing his homework, and getting it wrong.

About Beige

- The word "beige" comes from Old French meaning the color of undyed wool.

- Santa Claus used to be dressed in tan colors until cartoonist Thomas Nast painted him in a red suit for *Harper's Weekly* in the 1890s.

- Japanese emperors and their families traditionally wore neutral tones to embody the sense that the truth of nature is better than the flashy exhilaration of bright fabric.

- Beige was a favorite of 1930s American interior designer Elsie de Wolfe. On seeing the Parthenon in Athens she exclaimed, "It's my color!"

- In January 2002, scientists at Johns Hopkins University announced that they had discovered the color of all the light in the universe . . . and it was beige. The color was quickly renamed "cosmic latte" by the team.

Right: For thousands of years, Hindus in India have celebrated the arrival of spring by throwing brightly colored water or powder over each other in the festival of colors known as "Holi." Traditionally the colors came from herbs and flowers, but today most Holi colors are industrial.

Self-portrait of William Perkin at age 14, 1852

MAUVE CHEMISTRY PROJECT GONE WRONG

Mauve silk day dress, Great Britain or France, 1873

It was Easter vacation 1856, and 18-year-old chemistry student William Henry Perkin had been given a new material to experiment with. At that time London's streets were mostly dark and unsafe. But the city had begun installing coal gas street lamps. As more street lamps were put in, more and more of a gooey black by-product, coal tar, was piling up at the gas plant. To most people it seemed like useless industrial waste, but scientists were discovering that the two basic elements of coal—hydrogen and carbon—could form into large numbers of "hydrocarbons," each apparently with different and exciting properties.

Perkin's assignment from the Royal College of Chemistry, where he was a star student, was to use this coal tar to make a cure for malaria. (The only known cure came from the bark of the South American cinchona tree, a relative of the madder plant. The remedy was named "quinine," and we mostly know it as an ingredient in the fizzy soda originally called "tonic" because it was known to be good for you.) Quinine was made of organic matter, and coal was formed about 300 million years ago from the remains of vegetation, so the idea wasn't as weird as it might sound. But it wasn't

Mauve sample from *The American Practical Dyer's Companion* by F. J. Bird, 1882

working. From his tiny laboratory on the top floor of his parents' home in East London, Perkin simply couldn't make the right chemical compound. But one night, when washing out his flasks in some despair, he noticed a curious dark residue. "The solution of it resulted in a strangely beautiful color," he told a journalist years later. "You know the rest."

"The rest" was that the strangely beautiful new dye happened to be exactly the shade of soft, luminous violet that ladies in Victorian England and the rest of Europe and America were looking for. And, moreover, it was a stable dye, very good on silk, and very cheap to make. Perkin first called his color "Tyrian purple," after the dye that sent the Romans so crazy nearly 2,000 years before.

But classical references don't always make great brand names, and he soon renamed it "mauve" or "mauveine" after the French word for the mallow flower, which has petals the same color.

Oh, the world went mad for it! There were mauve dresses and mauve sofas and mauve carpets and mauve curtains and mauve collars for pet dogs. In 1859, the English journal *Punch* named this craze the "Mauve Measles." Even widows could wear mauve, as the church allowed violet for mourning in the second year. In 1862, a year after her beloved husband Prince Albert died, Queen Victoria made an appearance in a mauveine dress, causing sales to soar. Perkin became a millionaire by his early 20s.

After Perkin filed his first patent in 1857, just about every chemical company in Europe started testing coal tar to see what else was in there. They found so many things that are familiar today: food preservatives, fertilizers, medicines, perfumes, and explosives. Saccharine was discovered by a researcher into coal tar at Johns Hopkins University in Baltimore, who one lunchtime noticed that his sandwiches tasted sweet.

And when mauve fever subsided there were other new and brilliant colors to be made. In 1859 an intense, dark red coal tar dye was invented in France. Its first name, "fuchsine" (from the reddish-purple flower fuchsia) was too easy to mispronounce, and it got better sales when renamed after a battle that year in the town of Magenta in northern Italy. A coal tar version of madder red was invented in 1869. It was named "alizarin" after one of the color components of natural madder. Nine years later a synthetic indigo was invented in Germany, and that's the color blue jeans are dyed with today. The mass production of colorful clothes, fabrics, pigments, and dyes had begun.

Portrait of the Marquise de Miramon, née Thérèse Feuillant by Jacques Joseph Tissot, 1866
A swatch of fabric from the original pink velvet gown in the portrait, possibly dyed with magenta or another coal tar dye, is in the Getty collection along with this painting.

Perkin's mauve was the first modern synthetic dye, but it was not the first modern synthetic pigment. And, curiously, that one, too, a century and a half earlier, had been discovered entirely by mistake.

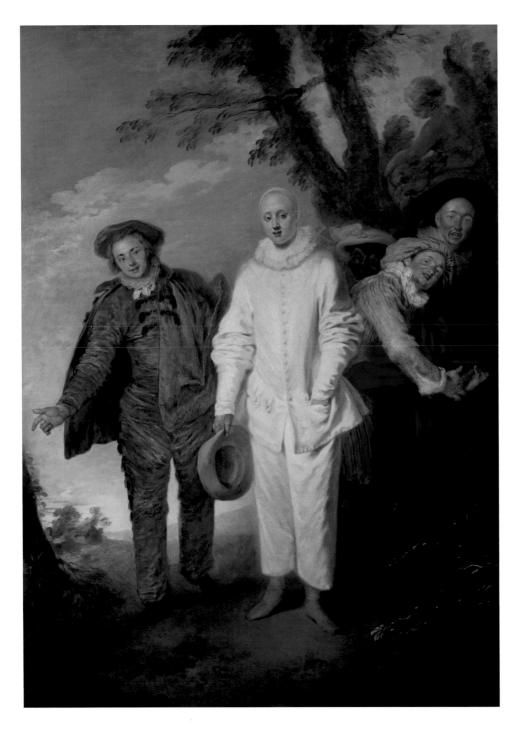

The Italian Comedians by Jean-Antoine Watteau, about 1720

The Grand Canal in Venice from Palazzo Flangini to Campo San Marcuola by Canaletto, about 1738
 Such depictions of Venice, with Prussian blue canals, were painted for wealthy British tourists, who would buy them as souvenirs of their Grand Tour of Europe and hang them in their stately homes.

Johann Jacob Diesbach was under pressure. The Berlin dye-maker had promised to make a batch of red cochineal dye for a client, and on this particular day in 1703 he was running late. He had the dried cochineal, and he also had iron sulfate (which had been used to make oak galls into ink in medieval times). But what he didn't have was fresh potash.

As its name suggests, potash comes from pot ash, traditionally made by soaking wood ash in water stored in clay pots. Potash is so useful that, when the chemical element it contains was identified, it was called "potassium." In the periodic table this is denoted by the letter K. That is partly because P was already taken by phosphorus. But it's also because in medieval Latin potash was called *kalium* from the Arabic *al qaliy*, meaning "burned ashes." In Germany potassium is still called *kalium*; the English took the term to make the word "alkali," which is one of the element's key characteristics. Potash is still used in soap and cleaning products and curing meat. But what Diesbach needed it for (and what it is still used for today) was as a mordant, making dyes stick to fabric.

Prussian BLUE THE BLUE THAT WAS SUPPOSED TO BE RED

Luckily, Diesbach spotted some potash in a corner, waiting to be thrown out. It had been rejected because it had somehow come into contact with animal blood. But Diesbach had no choice, and he used the contaminated potash. What harm could it do? Cochineal and blood were both red, so making a red dye would be no problem, right?

Not right. When Diesbach looked at his vat, he was amazed to see that the dye had come out blue. He did some experiments and discovered that cochineal had nothing to do with the end result at all. In fact, it was a pretty complicated (and unlikely) chemical reaction altogether. The potash had reacted with the blood to make what became known as potassium ferrocyanide. When Diesbach had mixed this with the iron sulfate in the dye vat, he had accidentally made another compound, iron ferrocyanide. And that one was a very splendid blue indeed.

The blue became known as *Berliner Blau* (Berlin blue) in German-speaking countries, and "Prussian blue" in English-speaking ones. "Nothing is perhaps more peculiar than the process by which one obtains Prussian blue," wrote the French chemist Jean Hellot in 1762. "And if chance hadn't taken a hand, you'd have to admit that a profound theory would be necessary to invent it."

When this new blue was announced (in Latin) in the Berlin Academy's publication *Miscellanea Berolinensia* in 1710, there were many artists eager to experiment. One was the French artist Jean-Antoine Watteau, who in around 1720 painted a canvas called *The Italian Comedians* using Prussian blue. The Venetian artist Canaletto also used the new paint very early on, around 1721. He used it for his famous *vedute* (Italian for "views") of the canals in his home city. Prussian blue was an excellent color for water.

In 1842 the English astronomer Sir John Herschel thought of a rather unusual application for Prussian blue. Standing in the dark in his home in Bath, he covered a piece of paper with ammonium ferric citrate and let it dry. He already knew that if he shone light onto that paper and then plunged it into a tub of potassium ferricyanide it would turn Prussian blue. But his new idea was to put an object between the light and the paper. The places where the object had kept light from hitting the paper stayed white.

Blueprint, New building for Duveen Brothers, New York City. Elevation by René Sergent, 1910

Equisetum sylvaticum by Anna Atkins and Anne Dixon, 1853
 One of Sir John Herschel's friends was botanist Anna Atkins. In the 1840s she applied his techniques to making mysteriously beautiful images of algae and plants by suspending them between the light source and the paper. Atkins is thought to be the first woman to create a photograph of any kind.

The rest turned blue as before. The result was a pale image on a deep blue background that he called a "cyanotype" (from the Greek words for "blue" and "impression").

That was clever and led to some lovely, strange pictures. But his next stroke was genius. What if he drew a diagram on a piece of translucent tracing paper and held it between the lamp and the paper, such that the lines of the diagram would keep the light from hitting the paper? When he developed the print, the resulting white lines on a blue field created what we now call a "blueprint." Architects found it useful straightaway. Up until then they had to copy everything by hand. Now they could make copies for everyone—the client, the builder, and the designer. Blueprints were the first form of photocopying.

Over the years the word "blueprint" became another way of saying you have a fixed plan. But unlike Prussian blue as a pigment for paint, the processed blueprints themselves are not very fixed. In 2010 scientists at the Getty tried a microfading experiment on one of the blueprints in their collection. Microfading is a way of testing how the color on objects would fade in ordinary sunlight by speeding up the process several thousand times. They shone strong light on a half-millimeter dot of the blueprint, "and the dot just vanished," says Getty Conservation Institute scientist Jim Druzik. "It went so quickly. In a couple of minutes we had to switch the machine off." The fading of Prussian blue is, incidentally, sometimes reversible, just by putting it back in the dark.

How Prussian Blue Revived an Ancient Japanese Art Form

Colored woodblock printing was an old tradition in Japan, but by the 19th century it had fallen into disfavor—partly because it seemed old-fashioned and partly because there was no lasting blue ink. The blues the Japanese did have, based on indigo plants, would fade so quickly that the prints couldn't be put on display for very long at all. Then in the 1820s Prussian blue came to Japan. It was a bold color that spoke of modernity and industry and the West (which was attractive to younger Japanese, especially as trade had officially been closed with Europe since the 1630s). And it reinvigorated the old woodblock tradition. The way woodblocks worked was that artists would make a design and then carvers would engrave a different block for each color, which would then be printed on top of one another. Printing houses would make thousands of copies on cheap paper, which they would sell for a few coins each. A century or so later the simple, strong compositions would inspire Manga comics.

When Dutch artist Vincent van Gogh saw these pictures in Paris in the 1880s, he was amazed at how minimal lines and colors could do so much in a composition. It was one of the great influences of his life.

Suraga Street by Utagawa Hiroshige, around 1856–59
This is an unusual, symmetrical woodblock scene of one of the busiest streets in Edo (the former name for Japan's capital city, Tokyo). There's a cloudy image of Mount Fuji in the distance and a textile shop on the left which today is Mitsukoshi, one of Japan's biggest department stores.

Emerald GREEN THE MYSTERY OF THE POISONOUS WALLPAPER

About Green

• In English the word "green" is related to the Anglo-Saxon *growan*, meaning "to grow."

• Future U.S. president George Washington was obsessed by the green verdigris paint of his new dining room, and during the Revolutionary War he often wrote home from the battlefield, to find out how the decorating was going.

• In 16th-century Persia, artists made green paint by hanging broadswords made of thin copper over a well for a month. Then they scraped off the corrosion as a pigment.

• One of the great mysteries of biology is, why do green plants reflect *away* the strongest light in the spectrum? As near as anyone can figure, plants found a compound that worked and stuck with it through the eons. It's called chlorophyll, named by combining the ancient Greek *khloros* (pale green) with *phyllon* (leaf).

• Malachite is a semiprecious green stone that can be ground up into paint. The ancient Egyptians used malachite as eye shadow to protect their eyelids from the harsh sun.

• In ninth-century China there was a kind of green porcelain that only emperors could own. They called it *mi se*, pronounced "mee-ser," meaning "mysterious color."

The Ransom by John Everett Millais, 1860–62
At the time Millais painted this story of a father giving money to a kidnapper for the return of his daughters, bright green wallpapers were all the rage in Victorian Britain.

In 1775 the Swedish chemist Carl Wilhelm Scheele made a new paint. It was a bright and shocking shade, reminiscent of deep emerald. He called it "Scheele's green." It became popular for patterned wallpaper for children's bedrooms, and for carpets, clothes, and artificial flowers, and it stayed in fashion for a century.

Yet this color was a killer. Children and invalids died from sleeping in their green-patterned rooms; a Persian cat locked in an emerald-painted bedroom was found covered in pustules. The Victorians used it sometimes as a food dye. In 1860 a chef made a spectacularly green blancmange for a dinner in London. Everyone talked about it

The Emperor Napoleon in His Study at the Tuileries by Jacques-Louis David, 1812

In 1821 Napoleon died in exile on St. Helena Island in the middle of the Atlantic Ocean. When a lock of his hair was tested in the 20th century, it showed he had been in contact with arsenic. Was he poisoned? Or was it from the wallpaper in his bedroom, which had long since been redecorated? It seemed there was no way to learn the truth. In 1980 a BBC radio program discussed the mystery. And one of the listeners had an ancestor who had visited St. Helena decades before and had naughtily torn off a strip of the wallpaper in Napoleon's bedroom as a souvenir. It showed small green fleurs-de-lis designs on a lighter background. When the wallpaper sample was analyzed, the fleurs-de-lis had traces of Scheele's green. The island air was humid, and by that time Napoleon was weak. If the paint didn't actually kill him, it could certainly have contributed to his fatal illness and account for the poison in his hair.

Even as late as 1950 the United States ambassador to Italy, Clare Boothe Luce, fell sick from arsenic poisoning. The CIA suspected the Soviets and sent a team to Rome to investigate. They eventually found that the ceiling in her bedroom was decorated with pigments full of arsenic. A new washing machine had been installed in the room above. Its juddering had released arsenic dust, which she breathed in as she slept.

The terrible thing is that Scheele knew from the beginning his green was no good. He had sent a letter to a friend in 1777 saying he wondered whether users should be warned that the paint was poisonous. But he decided to go ahead with it anyway. By the end of the 19th century the dangers were publicly known, but still artists and decorators continued to use it because it was so very bright.

in wonder, but later three of the diners died. Scheele's green was copper arsenite (a later version called "emerald green" had copper acetate added), and it contained that poisonous element, arsenic.

Arsenic makes very bright colors. Before Scheele's green, there were two ancient pigments containing arsenic. Orpiment means "gold pigment," and it is very bright. Alchemists used it a lot, hoping it would transform into gold. Its cousin, the red pigment realgar, which means "dust of the cave" in Arabic (*rahj al-gar*), was popular in China, sometimes in carvings, and also to make white flames in fireworks.

How We Perceive Colors

Colors exist only because our minds create them. The universe is pulsating with energy we call electromagnetic waves. These range hugely in size. Cosmic waves move in wavelengths of about a billionth of a millimeter, while long-range radio waves are sometimes several miles wide. Between them is a whole gamut of waves—infrared and TV and gamma and X-rays. But although we've developed scientific instruments to pick up all of these, human eyes can detect only a tiny portion: the ones with wavelengths between 0.00038 and 0.00075 millimeter. We quite naturally call these "visible light." When our eyes see the whole range of visible waves together, our brains read the experience as "white." When some of the wavelengths are missing, they see it as a "color."

So when we see "red," what we are actually seeing is that portion of the electromagnetic spectrum with a wavelength of about .0007 millimeter, *when the other wavelengths are absent.* Pigments have the ability to absorb some visible light and reflect the rest. So paint made with a red pigment absorbs the blue and yellow wavelengths from the white light around it and rejects the red, so red is the color we "see." But what happens when there is no white light? If you pull down the shades and turn off the lights, is this red bowl still red?

Glass bowl, Greece or Rome, end of first century BC–beginning of first century AD

Black and White and Sepia WHAT YOU CAN'T SEE IN PHOTOGRAPHS

The English inventor of the first photographic negative, William Henry Fox Talbot, called them "mousetraps," although today we call them "cameras" (which means "rooms" in Latin). Whatever you call them, these little lightproof boxes with a lens and shutter on one side and a light-sensitive material on the other played an enormous role in changing art. When photographs became affordable and popular in the mid-19th century, they were truly wonders. Imagine: ordinary people having portraits of themselves, after sitting still just for a minute or so!

Yet it wasn't always pleasant to see yourself without the intervention of a portrait painter. One commentator wrote that "the common remark upon showing your . . . picture to friends is 'Well, it isn't a flattering portrait, but it must be *like*, you know.'" It was worse, he said, if you tried to make a special face for the camera. "If ladies, however, must study for a bit of effect, we will give them a recipe for a pretty expression of mouth. Let them place it as if they were going to say prunes"—a different approach from today's "say cheese."

The technology was developed in 1839 by Talbot in England and, slightly earlier, by Louis Daguerre in Paris. It depended on opening the shutter for the right amount of time to project the image in front of the lens onto the light-sensitive material inside the camera. For daguerreotypes the light-sensitive material was a copper plate covered with a thin layer of silver that had

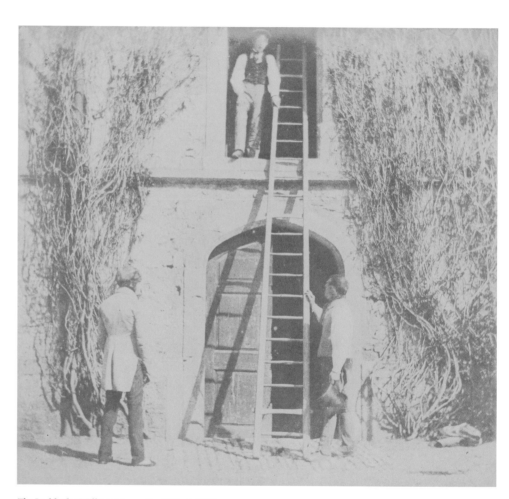

The Ladder by William Henry Fox Talbot, 1844
 "When the sun shines, small portraits can be obtained by my process in one or two seconds, but large portraits require a somewhat longer time." This was one of 24 prints included in William Henry Fox Talbot's *The Pencil of Nature*, the first commercially published book to include photographs. The barn was on the Lacock Abbey estate in southwest England, which Talbot inherited from his father in 1800, five months after he was born.

been exposed to iodine. Talbot's invention was closer to what became film photography. He used paper, and his process created a negative that could be used to make one copy after another. But however they were formed, there they were: images in black and white that showed what the camera had seen and what you looked like to other people.

So where were artists to go if their monopoly on realistic depiction was over? There was one really obvious thing that photographs could not do . . . yet. Early photographs were shades of gray, or sometimes a kind of brown called "sepia," made from the ink of cuttlefish (*sepia* in Italian). Some photos were hand-painted with colored pigments, like the portrait of the girl below, but although charming, these didn't look realistic.

And so color is what a new movement of artists turned to. Photographs might have taken away some of the fun of making amazingly exact images, but with the help of Chevreul's book there was space for painters to explore something old in a new way: harmonies of color.

Female Model Wearing a Tiara, Paris by Alphonse Maria Mucha, 1899

Portrait of Edgar Allan Poe, 1849
This daguerreotype of American mystery writer Edgar Allan Poe was taken in 1849, just a few months before he died at age 40. It would have been particularly spooky for its viewers, as in 1842 Poe published a horror story titled *The Oval Portrait*, about a portrait of a young girl that was so realistic it seemed to be alive.

Portrait of a Girl in Blue Dress by Antoine Claudet, about 1854
It was hard to make hand-painted daguerreotypes like this look realistic, but they were popular anyway.

Manganese VIOLET MONET GOES OUTSIDE

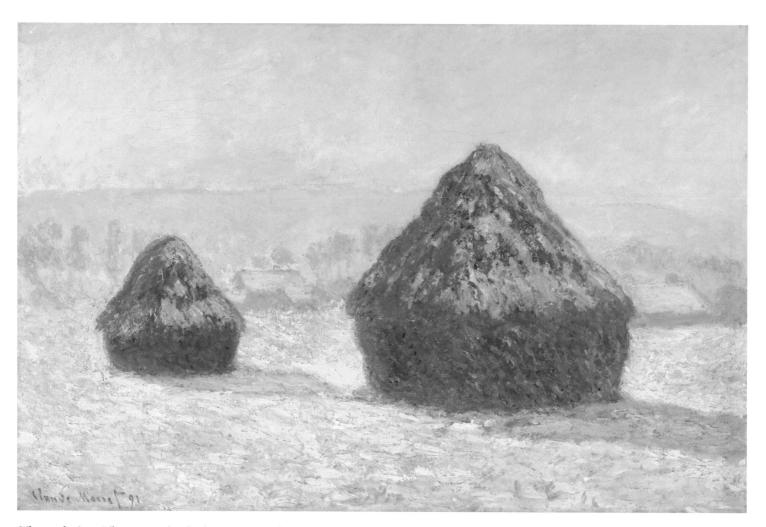

Wheatstacks, Snow Effect, Morning by Claude Monet, 1891

Claude Monet was alarmed when he heard that his local farmer wanted to use these wheatstacks to feed his animals, so he paid for them to be untouched over the winter. He wanted to paint them in all sorts of weather and light.

It had all started because the American portrait painter John Goffe Rand was frustrated every time he wanted a bit of paint. At the time, paints were stored in little squares of pigs' bladder, tied up with string. When artists wanted to use some they would pierce the skin with a tack, squeeze the paint through the hole, and then mend the hole with a

special puncture repair kit. The bladders would often burst, which was messy, and it was annoying to be mending little punctures when you really wanted to be painting. So Rand invented a collapsible tube, made of tin and sealed with pliers. He patented it in 1841. Artists now could go outside to paint without all the trouble and mess.

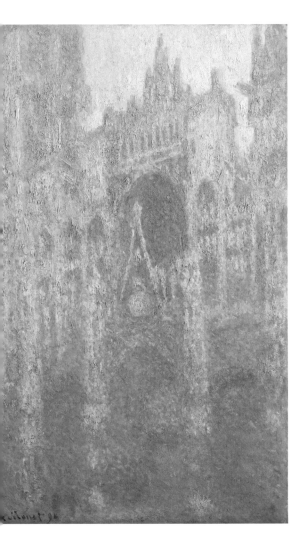

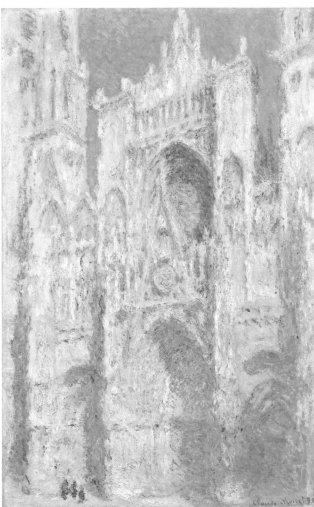

Far left: *The Portal of Rouen Cathedral in the Morning Light* by Claude Monet, 1894

Rouen Cathedral, West Facade, Sunlight by Claude Monet, 1894
In the towers at the top, and as a misty form at the center of the painting to the left, are stripes and circles of yellow. Yellow is the complementary color for violet, and the colors look more vivid because they are together.

Without oil paints in tubes "there would have been no Cézanne, no Monet, no Sisley or Pissarro: nothing of what the journalists were later to call Impressionism," the painter Pierre-Auguste Renoir once told his son, Jean. It was not only possible to have palettes with many more colors (before, with all that piercing and mending, you couldn't have too many, as by the time you were ready to use them all they'd have started to dry). And what is more, in the 19th century there were suddenly dozens of dazzling new pigments with which to fill the metal tubes.

One of them was manganese violet. It was the first opaque, pure, affordable, mauve-colored pigment, and it was seen as a wonder. Before it was invented in 1860, artists had to mix red and blue to make purple, but now they could squeeze it straight out of a tube. Impressionist artist Claude Monet found it invaluable, because his passion was exploring shadows. And he knew—he just knew—that shadows were not actually black. In fact, he knew it so well that sometimes he left his black paint behind, and so did many other Impressionists for a while. "There is no black in nature," was the refrain, although in the end, many of them snuck it back. It is useful, black.

Violet is the opposite of yellow in Chevreul's system of complementary colors, and Claude Monet wanted to investigate in paint whether the yellow Sun left violet shadows (although, if you look closely at his paintings, Monet mixed many other colors into his shadows as well). He also wanted to study what happened to light at different times of day and year, and the only way to do this was to make pictures at the same time each day and to keep painting the same subject again and again and again over several years. By the third or fourth canvas he was no longer studying form. He knew what that stack of wheat or water lily pond

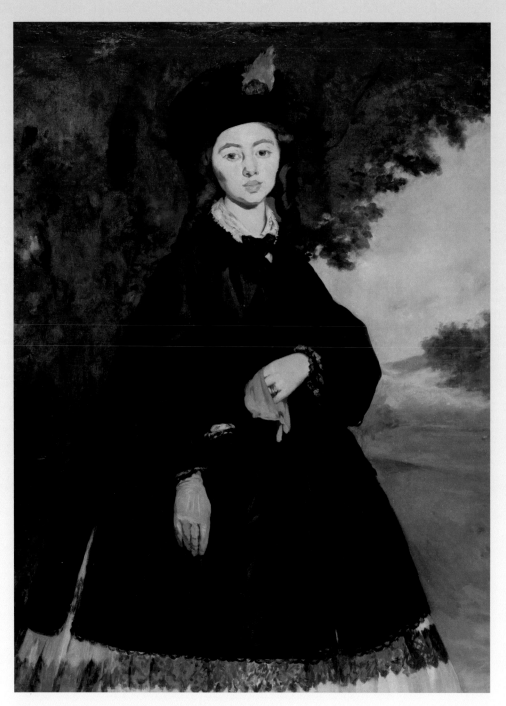

Portrait of Madame Brunet by Édouard Manet, about 1860–63

Black Is the New Black

Black was a color for mourning, but since the French Revolution in 1789, many people in France had started to wear it for everyday. It was sophisticated, and most of all it showed they had moved on from that frivolous generation that loved Pompadour pink and cerulean blue. And since the arrival of coal tar colors, it was actually possible to dye clothes a deep black quite cheaply. Édouard Manet painted this portrait of a friend's wife, Madame Brunet, wearing "the new black" at the same time he was experimenting with the new, looser painting style that would evolve into Impressionism. Madame Brunet is supposed to have burst into tears when she saw the painting, saying she never wanted to see it again.

looked like. What he was trying to do was work out something more important than their appearance. He wanted to paint the *impression* they gave, and he wanted to do that through color.

The wheatstacks were first. Monet found them in a field just outside his house at Giverny in Normandy. He used to pop out and visit them regularly for a few hours through the winter and spring of 1890 to 1891, carrying his folding stool with canvas seat, a portable easel, and a large parasol. He was exploring how our minds perceive shapes by the light they reflect. And he was also exploring shadows. If you have a red thing, does it make a red shadow? Or a green one (the opposite of red on the color wheel)? Or a gray one?

For his Rouen Cathedral series, Monet rented the front room of a lingerie shop opposite the cathedral, set up 10 canvases all around him, and as the light changed over the hours he moved from canvas to canvas. He completed 30 paintings in three years, and each showed a different moment of light. And what Monet demonstrated is that at different times of day and during different weather conditions, the limestone on the cathedral (which most people would describe as a rich cream color) absorbed light from different parts of the spectrum and then reflected different colored light back. "Everything changes, even stone," he said afterward. He painted the stones in reds, oranges, yellows, and—as different from cream as you can get—cobalt blue and manganese violet. "I have finally discovered the true color of the atmosphere," Monet said. "It's violet. Fresh air is violet. Three years from now, everyone will work in violet."

Shadows on the Red Planet

Try this: go outside on a sunny day and bring a white piece of paper. Cast a shadow onto the paper using your hand. You'll see that the shadow is a gray that is slightly light blue. That's the effect of our own planet's blue skies. But if you happened to be standing on Mars when you cast your shadow, it would be a grayish orange.

Jim Bell is an astronomer and also a landscape photographer who, like Monet, became fascinated with the interplay of light, shadow, and color in the outdoors. He was in charge of the unique panoramic cameras for NASA's *Spirit* and *Opportunity* robotic explorers, which landed on Mars in 2004 and continue to send remarkable images back to Earth. Getting the colors right with space cameras is tricky business, says Bell. But you can send along an object whose colors you already know and then take pictures of it within the new landscape. If you get the "known" colors right when you process the photograph, then you can assume that the "unknown" colors are also correct. The Mars rovers took along calibration targets with grayscale rings, color patches, and also a shadow-casting post to help measure the color effects of Martian daylight. These allowed Bell and his team to produce accurate pictures of Mars's salmon-pink sky and grayish-orange shadows.

A view of Mars taken by the *Opportunity* rover, 2012
You can see the shadows cast by the setting sun behind the rover and by the MarsDial in the lower left.

Photometric calibration target used by the NASA Mars rover *Opportunity*
Because Jim Bell invited TV science educator Bill Nye to a meeting about the Mars rovers, this calibration target also tells time. Nye took one look at the target's shape and said, "It's a sundial!" And since he is both a sundial fanatic and an engineer, he volunteered to help turn the target into a time-telling "MarsDial."

Chrome YELLOW COLOR FROM SIBERIA

Irises by Vincent van Gogh, 1889
 Van Gogh was influenced by Japanese woodblock prints, which were themselves influenced by the arrival of Prussian blue.

"My dear Theo. It just won't do to think that I'm completely sane," Vincent van Gogh wrote to his brother from France, soon after the night in late 1888 when he cut off his ear and handed it to a girl called Rachel, who worked in his favorite brothel.

When Van Gogh first started work as an artist around 1881, he used ochers and dark olive colors to portray farm laborers in Holland working in desolate landscapes. But then in 1886, at age 32, he moved to Paris. At first he was disappointed by the Impressionists. "You hear about the Impressionists and form a high opinion of them in advance," he wrote to Theo. "Then the first time you see them you are bitterly disappointed, you find it slipshod, ugly, ill-painted, ill-drawn, bad in color, quite wretched." He stayed in France, however, and befriended some of the artists as well as Père Tanguy, a colorman in rue Clauzel. Tanguy sold paints to most of the Impressionists, and if they didn't have any money, he would swap the colors for canvases.

Van Gogh eventually changed his mind about the Impressionists and developed a belief that "color, in itself, expresses something." He wasn't quite sure what it was, but his later work was a kind of journey to find out. He carried Chevreul's book with him wherever he went and experimented energetically with those ideas about the strange optical illusions that happened when colors were seen beside each other. He was so captivated with the Gobelins tapestry manufactory director's concept of entwining threads to produce the same effect as mixing paints that he kept balls of complementary-colored wool in a lacquered box.

Five months after that strange night when he cut off his ear, Van Gogh checked himself into the lunatic asylum at Saint-Rémy in the south of France. He had access to paints and canvases, and he painted copy after copy of his favorite paintings as therapy. In the single year he stayed at Saint-Rémy he produced around 150 paintings. At first he had to stay on the asylum grounds, but as he seemed to stabilize, he was allowed farther afield. One day in 1889 he went for a walk around the outside walls of the asylum, and in a farmhouse garden he found a flowerbed of blue irises and yellow and orange calendulas planted in red, flinty soil. He liked irises. They had that combination of yellow and blue that pleased him most in the world, so he painted them again and again. "There is no blue without yellow and without orange," he wrote to Theo. "And if you put in blue you must also put in yellow and orange too, mustn't you?"

The marigolds in the top left corner are a way to complement the deep violet blue of the irises. And if you look at the leaves, the green changes even among the irises. The ones in the foreground are bluer, and the ones in the middle are yellower. In a painting in which, if you look at it, there are no standard shadows or graded darker or lighter shades, Van Gogh is showing depth and distance by means of pure color.

Soon after, Van Gogh started to have regular psychotic episodes, and in one of them he was apparently found with his mouth full of chrome yellow oil paint after he'd squeezed it in, straight from the tube. Chrome yellow is extremely toxic and full of lead, so it could not have helped his mental condition at all.

The Discovery of Chrome Colors

An orange-red mineral discovered in Siberia in 1762 was named "crocoite" after the Greek word for the spice saffron, which is the same color. In 1797 French chemist Louis Nicolas Vauquelin figured out that crocoite contained an element nobody had discovered before. He called it "chromium" (after the Greek word for "color") because it has really unusual color responses to acid and alkali. If it comes into contact with acid, then it goes a deep lemon-yellow color, while with alkali it makes a bright orange pigment. These pigments were called "chrome yellow" and "chrome orange." Chrome colors took off immediately. In the 20th century chrome yellow was used for school buses and road signs in the United States, chosen because black letters on a yellow background are the easiest combination to read.

The Night Cafe by Vincent van Gogh, 1888

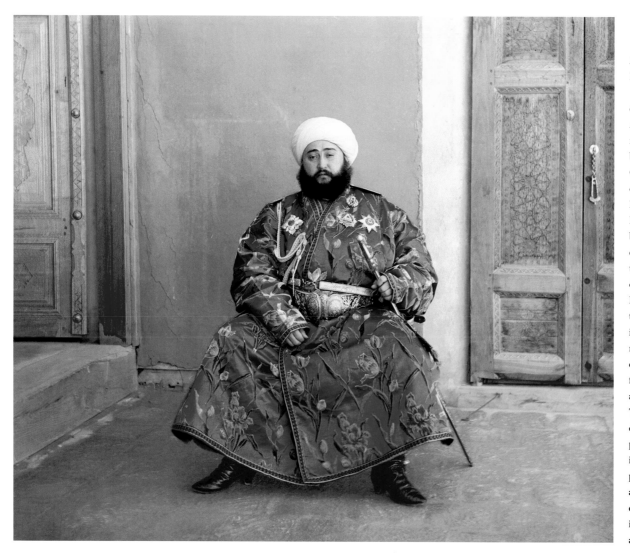

Emir of Bukhara by Sergey Prokudin-Gorsky, 1911
While the French were experimenting with Autochrome, German researchers in Berlin were busy improving on James Clerk Maxwell's three-color technique. In 1909, Russian nobleman Sergey Prokudin-Gorsky got the blessing from Tsar Nicholas II to set off across the Russian Empire to document it in full color. He had with him a camera that he had learned about in Berlin. It took three monochrome negatives, each with a different color filter, which could then be assembled in the studio. The result was an unprecedented colorful view of pre-Revolutionary Russia in more than 10,000 photos, including this astonishing portrait of the emir of Bukhara, in what is now Uzbekistan on the ancient Silk Road.

Patent Blue, Tartrazine, and Rose Bengal

MIX WITH POTATOES FOR DELICIOUS COLOR

The Scottish physicist James Clerk Maxwell made the first full-color photo—of a bright tartan ribbon—in 1861 by photographing it three times: once through a blue filter, once through a red, and once through a green. The resulting three glass slides were "color separations," which were then combined to project a full-color image. Then in 1878 the Musée du Louvre in Paris published the first book with printed color photographs. The trick was in the printing rather than in the camera, with up to 12 color separations used to print each image. And at 300 francs (the equivalent of around $17,000 in U.S. money today), the book was so expensive that only a few hundred copies were made. These inventions were interesting. But a camera designed to take color photographs: that was the Golden Fleece, the development so many people were hoping for. And it was French Lumière brothers Auguste and

Gold Lyre Table Clock by the Lumière brothers, about 1898

Still Life with Ornate Chinese Vase by Frederick S. Dellenbaugh, about 1910

Louis, already millionaires after inventing moving pictures (and starting the movie industry), who would work out a way to do it. They found it by mashing up potatoes.

By dyeing granules of potato starch in three batches (orangey red, violet blue, and green) and then shaking them up randomly, the brothers found that each granule kept the color it had been given. Mixed together, they created a substance that would act as three color filters at the same time. The granules were so tiny that when they were stuck as a single layer between two pieces of glass there would be about five million per square inch. The brothers then sprinkled black powder into any gaps, added a light-sensitive emulsion behind the plate, put it all carefully into a light-tight box at the back of the camera, and then exposed the plate in front of something colorful. The result is more like a photographic slide than a print. It looks like a piece of glass with a colored image floating inside it.

The challenge for the Lumière brothers was to find really bright primary-colored dyes that didn't

Kitty Stieglitz by Alfred Stieglitz, 1907

fade immediately. And the list of dyes used in the first Autochrome cameras reads like a shopping list for colorful food and medicine. The green was a mix of Patent Blue (used in the liqueur Blue Curaçao) and tartrazine (still found in some yellow store-bought cakes). The blue included gentian violet (used in ballpoint pens and ink-jet printers). And to make the bright red, Auguste and Louis Lumière mixed yellow tartrazine with rose bengal (still used by doctors to inject harmlessly into people's eyes to see any scarring) and erythrosine B (used in candied cherries and popsicles).

When the New York photographer Alfred Stieglitz attended the grand unveiling of the new "Autochrome" technique at the Photo Club de Paris in June 1907, he found the results captivating. "The possibilities of the process seem to be unlimited," he wrote in an article for the *London Photography* journal. "All are amazed at the remarkably truthful color rendering; the wonderful luminosity of the shadows, that bug-bear of the photographer in monochrome; the endless range of grays, the richness of the deep colors. In short, soon the world will be color-mad, and Lumière will be responsible."

Stieglitz bought several sets of Autochrome plates, took a number of pictures of his wife, Emmeline, and daughter, Kitty, with various props (Kitty with a blue dress, Kitty with a butterfly net, Emmeline with red flowers, etc.), and brought the new technology back to New York. And, although the Autochrome would never quite take off as Stieglitz and the Lumière brothers had predicted and hoped, the American art world did indeed, for a short while, go color mad.

Cadmium YELLOW LISTENING TO COLORS WITH KANDINSKY

When the Impressionists had their first show in Moscow in 1895, one of the visitors was a 29-year-old lawyer named Wassily Kandinsky. He stopped in front of one of Monet's *Wheatstacks* and had a revelation. He didn't like it. "It was the catalogue that told me it was a wheatstack. I could not recognize it as such. But what was quite clear to me was the unsuspected power of the palette, which had previously been concealed from me, and went beyond anything I had dreamt of." For the first time in his life, Kandinsky said, he really "saw" a picture. And that experience of seeing the world in a different way changed his life. A year later he had moved to Munich and was following his dream of becoming an artist. He would eventually become one of the most famous abstract artists of all time.

In 1911 Kandinsky had a second revelation. This time he was in a concert hall, listening to a piece of music by Austrian composer Arnold Schoenberg. By then Schoenberg had abandoned traditional composition to create music that allowed

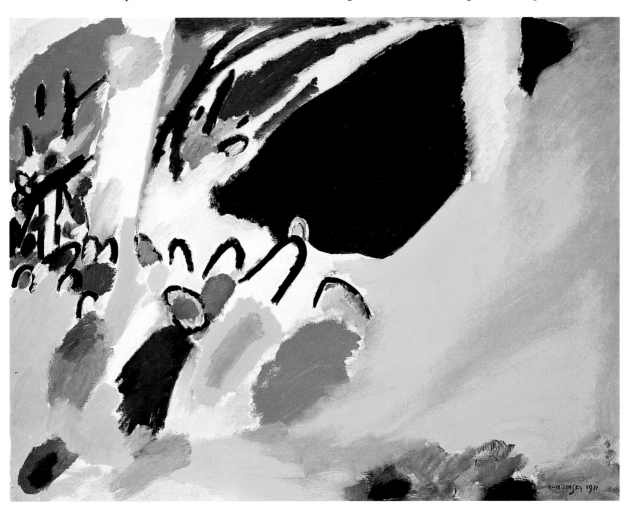

Impression III (Concert) **by Wassily Kandinsky, 1911**

the listener to "surrender the imagination to the play of colors and forms." Many hated his music (and in 1913 it would cause a riot in Vienna), but Kandinsky was transported. He returned home and painted what he had "heard." The resulting picture was a turning point in the use of color in art. It shows a piano as a black box surrounded by a field of the music that Kandinsky had heard that evening. And all the music was yellow. There was not one yellow but a mixture of yellows, black, possibly green: a concerto of bright. Kandinsky used at least three yellows in his palette: yellow ocher, chrome yellow, and another industrial color, cadmium yellow, which was discovered in 1817 and had been used for pigments since around 1840. It is the same toxic chemical used to make batteries.

Kandinsky was probably synesthetic. This meant his brain might have connected things that most people do not believe to be connected. Some synesthetic people "taste" numbers; others "hear" colors; others see colors as shapes (Kandinsky felt the form of a triangle was intrinsically yellow, squares were red, and circles blue). The Norwegian artist Edvard Munch imagined a scream of despair as swirls of primary red, yellow, and blue. And the Finnish composer Jean Sibelius was once asked what color he would like for his wood-burning stove. "F major," he answered, and it was duly painted dark green.

Having synesthesia was fashionable at the beginning of the 20th century: everybody who was anybody, it seemed, was suddenly getting extraordinary experiences from ordinary stimuli. This fad coincided with a change in attitudes about what art was or could be. After all, if the month of June can be violet, and a concert can be yellow, then it's logical to think that artists should represent more than the world we can easily see. Like those Byzantine icon painters a thou-

Starry Night by Edvard Munch, 1893
Munch had synesthesia and saw emotions as colors.

sand years before, artists were to use all the materials available to them to explore beyond the surface of things.

Kandinsky's favorite color was usually blue. "The deeper the blue becomes, the more strongly it calls man towards the infinite, awakening in him a desire for the pure and, finally, for the supernatural," he wrote. "The brighter it becomes, the more it loses its sound, until it turns into silent stillness and becomes white."

Throughout the 20th century, many of the things that had seemed to be universal truths about what art is were thrown up in the air, and when they fell to Earth they were broken. Artists became creative adventurers, working out new ways of doing things. Some of the greatest art was art that questioned what art was anyway. Some art deliberately didn't explore anything at all. As soon as you thought you knew what art was, somebody proved you wrong. Added to that, there were suddenly thousands of different colors and kinds of paints. With that, the history of color in art moved from a history of scarcity to a history of excess. There was so much of everything, artists had to redefine what was special.

Lithol RED
ENDLESS JOURNEY OF THE EYE

Mark Rothko, photograph by Hans Namuth, 1964

But what if there wasn't a piano, and there weren't people, and there were no "things" in a painting at all? What if the only "thing" was the color itself?

Throughout art history, painters had created limited fields of mostly one color: the black areas of Manet's fabrics, Van Dyck's brown backgrounds, Titian's ultramarine skies. Gainsborough's *Blue Boy* had been an experiment into the effect of large amounts of blue. But the artists always added other colors that, when put together, made something viewers understood as a "picture."

By the mid-20th century, artists were beginning to wonder what would happen if you stopped at just one or two colors. Would it represent something anyway? The idea was that if you started with the decision to make a painting, and then emptied your mind, applying pigments in whatever way seemed right, then something would emerge from your subconscious that might be interesting. "A painting is not about an experience," American Abstract Expressionist painter Mark Rothko said. "It is an experience."

The curious thing, when you see his paintings, which have huge fields of pure color, is that Rothko claimed he wasn't actually interested in color itself. It was just that he felt he had no option but to use it, given that he wasn't so interested in doing pictures of things. "Since there is no line, what is there left to paint with?" he once asked.

Rothko was more interested in what things looked like at the moment, rather than the future. He used many of the relatively new pigments made from coal tar. One was Lithol Red. It was invented in 1899 and was a bright primary used mostly for low-cost printing. It wasn't meant to last beyond today's newspaper or this week's magazine. Rothko never tested it to see if it was lightfast. And it wasn't. He used it in a series of five canvases painted as a gift to Harvard University to be displayed in a sunny refectory. They were mainly in crimson (Harvard's "school color") and were meant to represent the Passion of Christ. The dark Lithol Red tones represented Christ's suffering, and the lighter ones were the Resurrection. You'll have to take Rothko's word for it, though, as most of the crimsons are now pale blue. Today you can apparently trace the daily circuit of the sun around the room by the relative amounts of blueness in the panels. They are now in storage, although a team of curators is planning to "restore" them in a radical experiment that involves shining specially filtered lights on the paintings to give the impression of the original colors.

In the 1990s I interviewed Peter Boris of Pace Gallery in New York, which represents Rothko's work. They're not just paintings, Boris said. For him, the works were more like passages or corridors, or as if you could imagine the space between 0 and 1. "When you sit in front of them the color guides you to a place in your own perception, which you can't see, you just sense," he said.

He said it was impossible to describe it in words and advised sitting in front of a Rothko, concentrating for a good amount of time, like half an hour. I tried it later, on a bench surrounded by eight huge black-and-maroon Rothko paintings hung in a single room at Tate Britain in London. After a while, the paintings seemed less like paintings than windows in a chapel toward nightfall. And Boris was right. You can't describe the experience in words.

International Klein BLUE THIS IS NOT YOUR BLUE

In April 1958, an upcoming French artist invited the Paris smart set to an exhibition. Uniformed guards stood outside the entrance to the gallery, and the windows were painted and draped with a particular intense blue. But inside . . . inside . . . there was nothing at all. It was a pristine, pure white space, with no canvases in sight, and the evening ended in a near riot. If guests had read their invitations properly they might have guessed. The show was subtitled *Le Vide* (The Void). And the tale of the artist who thought it up is one of the great 20th-century stories about color in art.

Yves Klein's mother was so alternative she didn't have time to raise a kid, and so he spent half his childhood with his aunt in the south of France. He played truant and failed most of his exams. In the summer of 1947, when he was 19 and dreaming of adventures, he sat on a beach on the French Riviera with two friends, Claude Pascal and Armand Fernandez. They played a game about how they would divide the world among themselves. I'll have the land, said Armand, who became an artist. And I'll have all the words, said Claude, who became a poet. And Klein? He got the sky and its infinity.

The friends had this crazy dream of riding horses to Japan. Klein and Pascal even spent time in Ireland learning to ride. According to Klein's diary, they ate nothing but noodles for months. Despite having virtually no money, they also went to England and Spain and Japan, learning the languages

Blue World Globe by Yves Klein, 1962

and practicing judo. By 1954 Klein was the highest-ranking judo practitioner in France, with a 4th Dan black belt, but the French judo association didn't recognize it. Judo was clearly not going to make him rich, so he decided to be an artist. Both his parents were artists, and he'd had some practice. He couldn't really draw, but you probably didn't have to—not if you concentrated on mono-

chromes, canvases painted in just one color.

First up there was the slight problem of not having a body of work behind him. But then he simply made it up. He published a little book called *Yves Peintures* (Yves Paintings) with a preface by Pascal and 10 color plates showing single-colored rectangles as if they were monochrome paintings, with titles indicating where they might have

Louis XII of France Kneeling in Prayer by Jean Bourdichon, 1498–99
Yves Klein loved the mix of ultramarine and gold that was so popular during the Renaissance.

been done—Tokyo, Paris, Madrid. Except, of course, none of them existed. The book was a "work of art" and what it was showing was the illusion of art.

Klein's first submission to the top place in Paris for abstract art, the Salon des Realités Nouvelles, in 1955, was an orange monochrome. It was rejected. "If Yves would accept to add at least a little line, or a dot, or even simply a spot of another color, then we could show it. But a single color, no, no, really, that's not enough, it's impossible!" a Salon member told Klein's mother. Paintings had to begin with one color against another color. They couldn't just be one.

Klein would prove him wrong. The first Klein monochromes were green and pink and yellow and, of course, orange. But by 1957 he decided that blue, the color of the Riviera sky, was really his thing. He started to collect objects—blank canvases, souve-

nir plaster casts from the Louvre, a cast of Michelangelo's *Dying Slave* sculpture—and he spray-painted them all the same French ultramarine, which he asked his paint dealer in Paris to mix in a new resin named Rhodopas M60A. He chose it because it suspended the powder without weakening its intensity, so it appeared as a velvety matte surface, deep enough to swim in.

Then Klein gave the paint his own name—IKB (International Klein Blue). Technically what he was naming was the process, but everyone thought he was naming the color itself. In fact, do any search on IKB and you'll probably find reports that Klein actually patented the color, which is another illusion. It was, of course, outrageous to call a color after yourself (even if you were actually naming a process), but that was Klein's intention. He was a showman. And it did look spectacular. It had that intense violet tint that Renaissance artists had prized so highly.

Part of Klein's genius was recognizing the importance of scarcity. When you could get whatever color you wanted, in any kind of binder you wanted, paint colors weren't special anymore. They didn't have the same obvious meanings of preciousness or spirituality that had been so important with colors in the past. And Klein, by making a kind of paint rare and a little unique, with its manufacture a kind of mystery, had stumbled upon one of the great secrets of the history of colors in art. It is that, in addition to the effects and the contrasts, the complements and the saturation, once colors mean something more, they achieve something more.

Yves Klein gave the art world "his" color—and the experience of mentally diving into pure, unsaturated blue. He also gave it the story of Klein himself, who became more and more experimental, including hiring naked girls to smear themselves with his IKB

About Blue

- In the Jewish Talmud it was said that when Moses received the Ten Commandments on Mount Ararat, they were carved on blue stone.

- Blue only became the "traditional" color for boys in the 20th century. Before that, pink was just as popular.

- Picasso's "Blue Period" lasted from 1901 to 1904. All his paintings were almost entirely blue or blue green. He said it was because he had been depressed by a friend's suicide.

- Film director Alfred Hitchcock once gave a dinner party where everything—the flowers, tablecloths, utensils, and all the food—was blue, including blue steaks. "Oh this is interesting," he said, as he picked up a (blue) fork.

and roll around on paper. All these elements became part of the myth, and the myth became part of the art. And it was welcomed in the 1950s for many reasons. One was that the nuclear bombs that the United States dropped on the Japanese cities of Hiroshima and Nagasaki to end the Second World War changed everything.

If humans can destroy the world, what is the meaning of the world? In those postwar years people were questioning science, ethics, religion, and of course art, in ways they had never done before. And why, in that climate of chaos, shouldn't a single color be art? Why, indeed, shouldn't a gallery full of absolutely nothing still be art? Everything else, after all, was upside down.

Orange 36 and Violet 19 LICHTENSTEIN AND THE RISE OF THE SUPERHEROES

Superman swooped into the United States from planet Krypton in 1938, just as the Nazis consolidated power in Europe. Batman, Captain Marvel, and Wonder Woman quickly followed in 1939, 1940, and 1941. As the Second World War spread, there was a clear need for a new kind of hero or heroine. If an "axis of evil" was trying to take over the whole world, then people wanted to believe in someone who might possibly have the power to save us all.

That was the reason superheroes were created. But the reason they could be mass distributed—in color, and cheaply—was that color printing had become affordable. Comics could be for everyone. And the cheap inks they were published in, including that Lithol Red that Rothko used so disastrously,

Whaam! by Roy Lichtenstein, 1963

PART THREE | MODERN COLORS 109

provided a palette of bright, primary colors with bold outlines in black and highlights in white, which would be recognized and loved by generations of children.

American artist Roy Lichtenstein loved comics when he was growing up in 1930s and 1940s New York. He loved their bright, simple lines, he loved the adventures of the superheroes, he loved those funny Benday dots they were made from, invented in the 1870s by Benjamin Day. And from the early 1950s onward, he showed his love for comics by parodying them.

Many of Lichtenstein's paintings were taken straight from comics. He developed his own version of the Benday dot, which involved large single-colored painted spots

in strict grid patterns. The deliberate joke was that they looked as if they were cheap prints, but they actually required weeks of work. And holy gallons of turpentine, Batman! they sold. They sold for millions. In 2010 his 1964 Pop Art painting of a red-haired girl saying "Ohhh . . . Alright . . ." into a phone receiver fetched the astonishing price of $42.6 million at Christie's in New York. Three years later his parody of Pablo Picasso's Cubist paintings, called *Woman with Flowered Hat*, fetched more than $56 million. Another record. But why were these paintings seen as great art? Or at least as greatly valuable art? They were attractive and ironic, in bold lines and simple colors and, like many of Lichtenstein's other paintings, they reminded buyers of those happy moments in childhood where you escape with a comic from the cares of the ordinary world.

Cover of *Action Comics* featuring the first appearance of the character Superman, April 1938

Benjamin Day and Penny Press Printing

Benday dots are named after a real person. Benjamin Day was the son of Benjamin Henry Day, the founder of the *New York Sun* newspaper. Young Ben was an artist who studied in Paris and later did illustrations for magazines such as *Harper's*. He had this idea that there must be a way of getting color, cheaply, into newspapers and magazines. His process, introduced in 1879, was inspired by the way black-and-white photos were printed in newspapers by reducing tones of gray into different sizes of dots. Day's invention was more complicated. He used four plates of dots—black, magenta, cyan, and yellow—printed over each other in turn. Small dots, widely spaced, made a pale color; closer together they looked darker. And overlapping two colors made green, purple, orange, or pink. When color comics started being popular from the 1930s on, the obvious way to give them color was using the dots invented by Ben Day.

Close-up of Benday dots

About Orange

- In 1673 the U.S. city now called New York was named New Orange when the Dutch briefly occupied the area in the Third Dutch-Anglo War.

- Orange is a warning color. Dangerous parts of machinery are deliberately painted with it.

- Buddhists in Nepal pour orange dye over their white holy stupas, or sacred structures, to show they have given money to the temple.

- Alexander the Great washed his hair in saffron to give it a golden tint.

- Orange food really can make you see in the dark. Carrots, oranges, papaya, pumpkin, peppers, rutabaga, and apricots all contain carotenoids, which convert to vitamin A and are needed for good vision in dim light.

- In December 1999 a British pediatrician, Dr. Duncan Cameron, reported that a five-year-old girl had turned bright orange after drinking 1.5 liters a day of a drink called Sunny Delight. The betacarotene pigment additive had gone to her face.

But Lichtenstein's paintings did more than that. It's quite easy to make something that is pleasing. However, as we've seen in this brief tour of colors in art history, all "great" art over the years has also said something fresh about things people believed were important at the time. And in the 1950s, among other things, there was the question of what made "original" art original. If artworks could be easily and cheaply reproduced, using constantly improving methods of photography and printing, what was so important about buying the original? Why would you pay so much more for it, when a copy looks pretty much the same? Is it because the original has been touched by a person whose famous name is worth ten thousand times more than that of another person who is not famous? Is that the important thing? The touch?

Lichtenstein and other Pop Artists explored the subject by pushing it to its edge. They "made" paintings that they didn't actually touch except to sign them. So Lichtenstein's contemporary, Andy Warhol, created silkscreen prints of actress Marilyn Monroe and other celebrities, as well as silkscreens of mass-produced objects such as tomato soup cans, and he had assistants print them over and over in various bright colors as if they were postage stamps on a tear sheet. "Good business is the best art," Warhol once said, as these works sold for millions.

And meanwhile, in Lichtenstein's own studio, the artist would spend ages planning the paintings. But, especially in his last years, the paintings themselves were almost entirely done by studio assistants, whose names were not recorded on the works at all. So was that great "original" art? There is no clear answer, which is exactly the idea that Lichtenstein was playing with. "I'd always wanted to know the difference between a mark that was art and one that wasn't," he said.

Lichtenstein always used oil paints for the Benday dots (he needed the paint to dry slowly to get the right effect), but his favorite medium for the rest of his canvases was a brand of acrylic resin paint called Magna. It was the first acrylic paint, and when it was invented in the late 1940s the slogan was "Let's talk new Magna: the first new painting medium in 500 years." Lichtenstein loved it so much that when it was discontinued he bought up all he could.

Acrylic paints were developed in 1941 when an artist in New York brought a jar of acrylic resin to the paint-making team Sam Golden and Leonard Bocour and asked if they could add pigment so he could use it instead of oil paint. Golden and Bocour found a way of keeping the pigment very concentrated, so even when it was thinned with turpentine it would still give a strong, saturated color. After Bocour had made the paint there would always be a little left over, which wouldn't fit into the tube. "I would put it in a piece of wax paper and throw it in this basket," he said. Through the early 1950s, impoverished artists such as Mark Rothko, Barnett Newman, and Willem de Kooning (who loved these new acrylics because they would dry so much more quickly than oils) would drop by and see what treats they could pick up. They called it the "Bocour Bread Line."

In 2005 the Getty Museum in Los Angeles received a large 1984 outdoor aluminum sculpture by Lichtenstein called *Three Brushstrokes*. Years outside in the California sunshine had made the paint blister into little bubbles, and someone had tried to stop the damage in the 1990s by repainting it, meaning that the colors were different from the original ones. Conservators had also discovered that the red paint used in the restoration was not red paint at all. It was made

Three Brushstrokes by Roy Lichtenstein, 1984

by mixing Color Index Pigment Orange 36 and Color Index Pigment Violet 19. (The Color Index International list of colors had become necessary in the 1920s, when people realized how many random names there were for paints.) Put together, this particular orange and violet make an extremely bright "primary" tomato red commonly used in auto-body paint, which is made to last in harsh sunlight. In fact, the person who did the 1990s restoration probably used an off-the-shelf car paint.

The question was, what should the Getty do about this? For a work of art that was all about the process of painting, it seemed pretty important to get the painting right. And so after a great deal of discussion, the Getty made a radical decision. Lichtenstein had died in 1992, but when Getty conservators and scientists found that the studio assistant who had worked on the original was still alive and well, they decided to strip off all the paint, reprime it, and then get the same assistant to paint it all over again, this time using "real" red, as the artist had wanted: a first layer of red lead chromate, followed by a studio-made paint consisting of cadmium red Magna acrylic mixed with polyurethane clearcoat lacquer.

And then, to make sure the paints didn't fade this time, the Getty found a new space for their "outdoor" sculpture: inside.

The Trouble with Red Outside

The first mailboxes in England were green, until people complained they were always bumping into them. So beginning in 1874 they were repainted with a bright red silicate enamel. However, they quickly faded to sickly, uneven pink. People complained about the ugly color. But there was no bright paint that could outlast summer sun and winter frost. The only solution was to keep repainting. And even today, as the Getty found with the Lichtenstein outside sculpture, which is now kept inside, it is still almost impossible to get an outdoor paint that won't fade.

Visitors study untitled works by artist Dan Flavin at the Hayward Gallery in London, 2006
 In the early 1960s American Minimalist artist Dan Flavin gave up using paints or the found objects (such as crushed tin cans) that he'd made art out of up to then. And instead he made art out of colored fluorescent tubes. He found he could create all sorts of effects: "If you press an eight-foot fluorescent lamp into the vertical climb of a corner, you can destroy that corner by glare and doubled shadow," he said. Light is symbolic of many things in art, but Flavin insisted nobody should get too many symbolic ideas looking at his work. "It is what it is, and it ain't nothin' else," he said.

Painting with Light

PIXELS AS PIGMENT

In 2010 the British artist David Hockney became the proud owner of one of the very first generation of Apple iPad tablet computers, straight off the production line. He wanted it for a software application called Brushes, which, he could already see, from having practiced with a simpler version on his iPhone for two years before, would change his artistic life. Brushes allowed artists to put several layers of colors, adjusted for levels of transparency, on top of each other. It stored all the marks in order so they could be played back as a kind of movie,

which could be edited and corrected. It also allowed the artist to choose from thousands of different hues and shades while sketching in all sorts of seasons and light conditions, including near total darkness. Effectively, it enabled Hockney to use pixels as paints. And it solved that perennial issue of landscape painters of how the light keeps changing but the painting itself takes time to create.

"I can make some quick decisions," said Hockney, "and draw on any color background I want, for example, a very pale, transparent blue: the sky. Well I can put that

down in two seconds, then put in some faint clouds in three seconds." He spent seven months learning the technique, first drawing mostly with his fingers and thumbs and later with a computer stylus. He enjoyed how his artworks glowed on the screen, looking more like stained glass than paintings on paper or canvas. "What is really good about it is its speed," Hockney told Royal Academy of Arts curator Marco Livingstone in 2011. "You can get things down very fast, meaning you can capture quick lighting effects like nothing else. The spring is just spectacular this year and I am getting it down. The winter ones now look very wintry."

Today we no longer have to have special materials to make bright artworks. Colors are not just for the very rich or for people living in major trading centers. They do not have to come from far away, nor is one necessarily more expensive than another. If you can get access to a computer or tablet, millions of colors are available for you to use and play with.

We have gained the rainbow in its multipixeled magnificence, but there is also a danger. If we can feast on anything we like, we can sometimes fail to appreciate what we have in front of us. And if colors no longer mean wealth or rarity or sacredness or decay, or power or health or danger as they once used to do, then perhaps, with our multiple layers of luminous 3D effects and electrically colored computer lights, we will lose some critical layers of experience as well. And we will forget that colors in the real world are not just effects, but that they can really be, as well as symbolize, something important to life itself.

Discussion questions for reading groups and classrooms and other resources are available at www.getty.edu/education/brilliantcolor

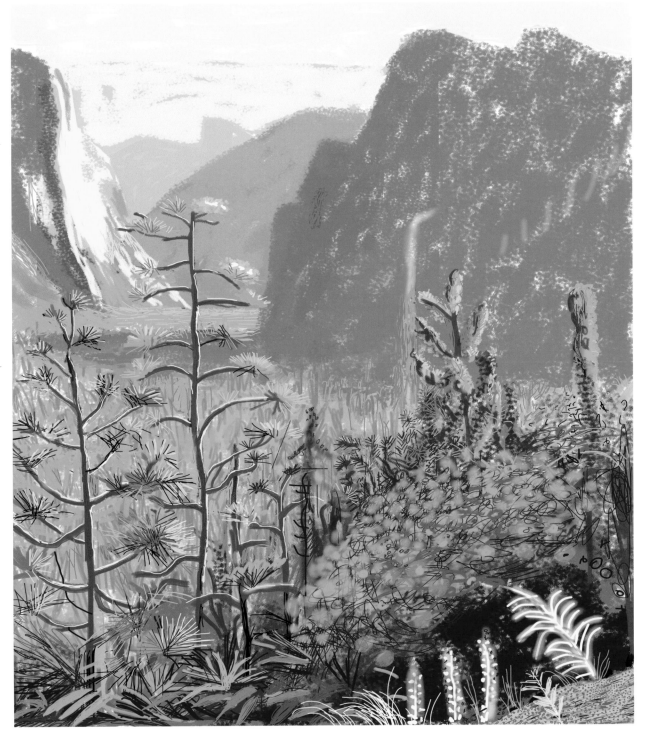

The word "pixel" is a combination of the two English words "picture" and "element." It means one of the millions of tiny illuminated dots that, when put together, form multicolored TV and computer images.

Yosemite I, October 16th 2011 by David Hockney, 2011
This iPad picture of Yosemite National Park was originally printed 12 feet high on six pieces of paper.

Illustration List

Abbreviations

The Getty Conservation Institute	GCI
The Getty Research Institute	GRI
J. Paul Getty Museum	JPGM

Cover: Pigments for sale at a market stall in Goa, India. CC 2.0. Photo: Dan Brady

Half-title page: Pigment scoops from Winsor and Newton. Image by kind permission of Winsor and Newton

Title page: *Byzantin from L'ornement polychrome* by Auguste Racinet. Lithograph by Jetot, 1869–1887. GRI 84-B13277

p. 7: Detail of agate bowl, Roman, 1st–2nd century AD. Agate, H: 1½ in. JPGM 72.AI.38

p. 8: Lascaux Cave, showing Upper Paleolithic paintings, about 15,000 BC. Photo: Sisse Brimberg/National Geographic Creative

p. 9, top: Two boys (discoverers of Lascaux Cave) and Robot, France, 1940

p. 9, bottom: Paleolithic wall painting depicting a bison from the caves at Altamira, Spain. Bildarchiv Steffens/Henri Stierlin/The Bridgeman Art Library

p. 10, top: Hands at the Cuevas de las Manos on Río Pinturas, near the town of Perito Moreno in Santa Cruz Province, Argentina, about 11,000–7,000 BC. CC 3.0. Photo: Mariano

p. 12: Photograph of a *pukumani* pole, Darwin Airport, Australia, 2011. Photo © Steve Passlow

p. 13: Dry streamed with ocher, making a natural paintbox, at Jumped Up Creek, Beswick, Australia, 2000. Photograph courtesy the author

p. 14, left: Tony Djikululu (Australian, 1938–1992), Gupapuyngu group, Milingimbi, Central Arnhem Land, *Fresh Water Turtle and File Snake*, about 1965. Natural pigments on eucalyptus bark, 18½ x 11¼ in. Kluge-Ruhe Aboriginal Art Collection at University of Virginia, 1994.0004.766. Courtesy the Kluge-Ruhe Aboriginal Art Collection of the University of Virginia/© 2014 Artists Rights Society (ARS), New York/VISCOPY, Australia

p. 15: Diagram with the Sun and phases of the Moon, from *De natura avium*, France (formerly Flanders), about 1275–1300. Tempera colors, pen and ink, gold leaf, and gold paint on parchment, 9³⁄₁₆ x 6⁷⁄₁₆ in. JPGM 83.MR.174.149

p. 16, top: Inlay in the form of an eye, Egyptian, 1540–1070 BC. Glass and gypsum, ⁹⁄₁₆ x 1¹³⁄₁₆ x ⅜ in. JPGM 2003.154

p. 16, bottom: Baboons painted on the walls of Tutankhamun's tomb, Egyptian, 18th Dynasty. Tempera on dry plaster. © J. Paul Getty Trust and Egypt's Ministry of State for Antiquities. Photo: Robert Jensen

p. 17: Conservators from the GCI examining the wall paintings in the burial chamber of the tomb of Tutankhamun as part of a collaborative project between the Getty and Egypt's Ministry of State for Antiquities to conserve the tomb. © J. Paul Getty Trust and Egypt's Ministry of State for Antiquities. Photo: Robert Jensen

p. 18, left: *Lekanis* (basin) with Thetis and Nereids carrying arms to Achilles, South Italian, late 4th century BC. Polychromy on marble, 12 x 23⅜ in. Per consessione del minstero per i beni e le attività culturali e del turismo—Soprintendenza beni archeologici per la Puglia Taranto/Archivio fotografico

p. 18, right: Infrared image of *lekanis,* JPGM

p. 19: White House, 1792–1800. James Hoban, architect. Library of Congress, LC-DIG-highsm-04961

p. 20: Sir Lawrence Alma-Tadema (Dutch, 1836–1912), *Pheidias and the Frieze of the Parthenon*, 1868–69. Oil on mahogany panel, 28⁹⁄₁₆ x 43 in. Bequeathed by Sir John Holder, Bt., 1923. Birmingham Museums & Art Gallery, 1923P118. Birmingham Museums and Art Gallery/The Bridgeman Art Library

p. 21, left: Statuette of Apollo, Greek, about 300 BC. Terracotta with polychromy, H: 8⁹⁄₁₆ in. JPGM 96.AD.266

p. 21, right: Head of Hades, Sicilian Greek, about 400–300 BC. Terracotta and polychromy, 10¾ x 8¹⁄₁₆ x 7⁵⁄₁₆ in. JPGM 85.AD.105

p. 22: Duane Hanson (American, 1925–1996), *The Cheerleader*, 1988, and *The Surfer*, 1987. Polyvinyl polychromed in oil, mixed media, with accessories. Collection of Mrs. Duane Hanson. © Estate of Duane Hanson/Licensed by VAGA/New York, NY. Courtesy Van de Weghe Fine Art, New York

p. 23, left: Joseph Nollekens (English, 1737–1823), *Venus*, 1773. Marble, H: 48¹³⁄₁₆ in. JPGM 87.SA.106

p. 23, right: Antonio Canova (Italian, 1757–1822), *Apollo Crowning Himself*, 1781–82. Marble, H: 33⅜ in. JPGM 95.SA.71

p. 24, top: Giovanni Battista Tiepolo (Italian, 1696–1770), *Alexander the Great and Campaspe in the Studio of Apelles*, about 1740. Oil on canvas, 16¾ x 21¼ in. JPGM 2000.6

p. 25: Attic red-figure *pelike*, Kerch Style, Greek, about 360 BC. Attributed to the Painter of the Wedding Procession (active around 362 BC). Terracotta, polychromy, gilding, 19 x 10¹¹⁄₁₆ in. JPGM 83.AE.10

p. 26, top: A scientist uses a Raman spectrometer to examine the pigments in the colored illustrations in *Historía general del Pirú* (JPGM 83.MP.159).

p. 26, bottom: Pigments in the painting *The Angel Taking Leave of Tobit and His Family* (JPGM 72.PA.17) are analyzed using X-ray fluorescence spectroscopy.

p. 27: Caspar David Friedrich (German 1774–1840), *A Walk at Dusk*, about 1830–35. Oil on canvas, 13⅛ x 17³⁄₁₆ in. JPGM 93.PA.14

p. 28, top: Engraved portrait of Aurelian, Roman, 260–280. Amethyst, ¾ x ⁹⁄₁₆ x ¼ in. JPGM 84.AN.856

p. 28, bottom: A French poster for the 1963 movie *Cleopatra*. akg-images

p. 29, left: Boucicaut Master and workshop (French, active about 1390–1430). *The Suicide of Queen Dido*, from *Des cas des nobles hommes et femmes*, Paris, about 1413–15. Tempera colors, gold leaf, and gold paint on parchment, 16⁹⁄₁₆ x 11⅝ in. JPGM 96.MR.17.41

p. 29, right: Engraved scaraboid, Greek, late 5th–early 4th century BC. Mottled green and yellow jasper, ¹⁵⁄₁₆ x ¹¹⁄₁₆ x ⁵⁄₁₆ in. JPGM 85.AN.370.7

p. 30, top: Wall fragment with a Maenad, Roman, 1st century. Fresco, 31¹⁵⁄₁₆ x 30⅜ x 3⅛ in. JPGM 83.AG.222.4.2

p. 30, bottom: Han Gan (Chinese, active about 742–56), *Night-Shining White*, about 750. Handscroll, ink on paper, 12⅛ x 13⅜ in. Purchase, the Dillon Fund Gift. New York, Metropolitan Museum of Art, 1977.78. © The Metropolitan Museum of Art. Image source: Art Resource, NY

p. 31, top: Fresco fragment, Woman on a balcony, Roman, about 9 BC–AD 14. 23⅝ x 17¹³⁄₁₆ x 1³⁄₁₆ in. JPGM 96.AG.172

p. 31, bottom: Christen Schjellerup Købke (Danish, 1810–1848), *The Forum, Pompeii, with Vesuvius in the Distance*, 1841. Oil on canvas, 27⅞ x 34⅝ in. JPGM 85.PA.43

p. 32, left: *Saint Luke*, from a gospel book, Ethiopian, about 1504–5. Tempera on parchment, 13⁹⁄₁₆ x 10⁷⁄₁₆ in. JPGM 2008.15.143v

p. 32, right: Calendar page from a psalter, Germany, about 1240–50. Tempera colors, gold leaf, and silver leaf on parchment, 8¹⁵⁄₁₆ x 6³⁄₁₆ in. JPGM 83.MK.93.3v

p. 32, bottom: *Desolate nayika*, Indian (Mughal), about 1775–1800. Painted paper, 19⅜ x 17¼ in. London, British Museum, 1999,1202,0.4.2. © The Trustees of the British Museum/Art Resource, NY

p. 33: Mummy with cartonnage and portrait, Romano-Egyptian, AD 50–100. Wax tempera and gilding on a wooden panel, linen and encaustic, 69 x 17⁵⁄₁₆ x 13 in. JPGM 91.AP.6

pp. 34–35: Chen Rong (Chinese, active first half of the 13th century), *Nine Dragons*, 1244. Ink and color on paper, 18⁷⁄₁₆ x 589³⁄₁₆ in. Francis Gardner Curtis Fund, Museum of Fine Arts, Boston, 17.1697. Museum of Fine Arts, Boston, Massachusetts, USA/The Bridgeman Art Library

p. 35: Alex "Defer" Kizu (American, b. 1971). *Sacred Writer* from *LA Liber Amicorum*, 2012. Mixed media, 12⅝ x 19¾ in. GRI 2013.M.8*
© The J. Paul Getty Trust

p. 36: *The Presentation in the Temple*, Byzantine, 13th century. Tempera colors and gold leaf on parchment, 8⅛ x 5⅞ in. JPGM 83.MB.69.129v

p. 37: Bernardo Daddi (Italian, active about 1312–48), *The Virgin Mary with Saints Thomas Aquinas and Paul*, about 1335. Tempera and gold leaf on panel, 47⅞ x 44½ in. JPGM 93.PB.16

p. 38: A hedgehog, from *De natura avium*, France (formerly Flanders), 1275–1300. Tempera colors, pen and ink, gold leaf, and gold paint on parchment, 9³⁄₁₆ x 6⁷⁄₁₆ in. JPGM 83.MR.174.82

p. 39: *Boys Hauling Nets*, possibly Simon and Peter, from the Abbey Bible, Bologna, about 1250–62. Tempera and gold leaf on parchment, 10⁹⁄₁₆ x 7¾ in. JPGM 2011.23.62

pp. 40–41: Artists' materials courtesy Nancy Turner

p. 42: Master of the Jardin de vertueuse consolation and Assistant (Flemish, active third quarter of the 15ᵗʰ century). *Alexander Attacks the City of Tyre*, from *Livre des fais d'Alexandre le grant*, Lille (written) and Bruges (illuminated), about 1470–75. Tempera colors, gold leaf, gold paint, and ink on parchment, 17 x 13 in. JPGM 83.MR.178.61

p. 43: Andrea Mantegna (Italian, about 1431–1506), *Adoration of the Magi*, about 1495–1505. Distemper on linen, 19⅛ x 25¹³⁄₁₆ in. JPGM 85.PA.417

p. 44: Master of Guillebert de Mets (Flemish, active about 1410–50), *Saint George and the Dragon*, from a book of hours, Ghent, about 1450–55. Tempera colors, gold leaf, and ink on parchment, 7⅝ x 5½ in. JPGM 84.ML.67

p. 45, left: Page from a manuscript of the Qur'an, Iran, about 1550–75. Ink, opaque watercolor and gold on paper, 20 x 13 in. Shinji Shumeikai Discretionary Fund. Los Angeles County Museum of Art, AC1999.158.1. www.lacma.org

p. 45, right: Engraved gem, Roman, 2nd century. Lapis lazuli, ¹¹⁄₁₆ x ⁹⁄₁₆ x ⅛ in. JPGM 83.AN.437.44

p. 46: Simon Bening (Flemish, about 1483–1561), *The Annunciation*, about 1525–30. Tempera colors, gold paint, and gold leaf on parchment, 6⅝ x 4½ in. JPGM 83.ML.115.13v

p. 47: Paulus Potter (Dutch, 1625–1654), *The "Piebald" Horse*, about 1650–54. Oil on canvas, 19¾ x 17¾ in. JPGM 88.PA.87

p. 48, top: Eugène Delacroix (French, 1798–1863), *The Death of Lara*, about 1824. Watercolor with some bodycolor and some underdrawing in graphite, 7¹⁄₆ x 10⅛ in. JPGM 94.GC.51

p. 49, left: Michelangelo Buonarroti (Italian, 1475–1564), *Studies for the Libyan Sibyl* (recto), about 1510–11. Red chalk, with small accents of white chalk on the left shoulder of the figure in the main study, 11⅜ x 8⁷⁄₁₆ in. New York, The Metropolitan Museum of Art, 24.197.2. © The Metropolitan Museum of Art. Image source: Art Resource, NY

p. 49, right: Titian (Tiziano Vecellio) (Italian, about 1487–1576), *Venus and Adonis*, detail, about 1555–60. Oil on canvas, 63 x 77⅜ in. JPGM 92.PA.42

p. 50, left: Martín de Murúa, scribe (Spanish, died after 1616). *Tupac Inca Yupanqui and a Quipucamayoc*, from *Historia general del Pirú*, Madrid and La Plata, Bolivia, 1616. Pen and ink and colored washes on paper, 11⅜ x 7⅞ in. JPGM 83.MP.159.51v

p. 50, bottom: Prickly pear infested with cochineal

p. 51, left: Circle of Raphael (Raffaello Sanzio, Italian, 1483–1520), *Portrait of a Young Man in Red*, about 1505. Oil on panel, 26½ x 20¾ in. JPGM 78.PB.364

p. 51, right: Workshop of Rogier van der Weyden (Netherlandish, 1399/1400–1464), *Portrait of Isabella of Portugal*, about 1450, later additions about 1500. Oil on panel, 18⅛ x 14⅝ in. JPGM 78.PB.3

p. 52, left: Joris Hoefnagel, illuminator (Flemish/Hungarian, 1542–1600), *Martagon Lily and Tomato*, from *Mira calligraphiae monumenta*, Vienna, 1561–62, illumination added 1591–96. Watercolors, gold and silver paint, and ink on parchment, 6⁹⁄₁₆ x 4⅞ in. JPGM 86.MV.527.102

p. 52, right: Jusepe de Ribera (Spanish/Italian, 1591–1652), *An Oriental Potentate Accompanied by His Halberd Bearer*, about 1625–30. Point of the brush with carmine red ink (from cochineal?); squared in pen and brown ink, 9¹⁄₁₆ x 5⁵⁄₁₆ in. JPGM 91.GA.56

p. 53: Anthony van Dyck (Flemish, 1599–1641), *Portrait of Agostino Pallavicini*, about 1621. Oil on canvas, 85⅛ x 55⅛ in. JPGM 68.PA.2

p. 54, left: Attributed to Quiringh Gerritsz. van Brekelenkam (Netherlandish, after 1622–1669 or later), *Family Group in an Interior*, about 1658–60. Oil on canvas, 23½ x 28⅞ in. JPGM 70.PA.20

p. 54, right: *Captain Teach Commonly Call'd Black Beard*, engraving from *A General and True History of the Lives and Actions of the Most Famous Highwaymen, Murderers, Street-Robbers*, 1742. The Art Archive at Art Resource, NY

p. 55, top: Han van Meegeren (Dutch, 1889–1947), *The Woman Taken in Adultery*, about 1941–42, right, on display at the Boijmans Van Beuningen Museum in Rotterdam, the Netherlands, May 2010. © ROBIN UTRECHT/epa/Corbis

p. 55, bottom: Lidded vase, Chinese (Kangxi), about 1662–1722. Hard-paste porcelain, with lid: H: 23½ in. JPGM 86.DE.629

p. 56: Head of an Angel or Saint, French, about 1410. Oxide glass paint and silver stain on tint glass with blue, ruby, and green pot metal, 18½ x 18½ x ⅜ in. JPGM 2003.34

p. 57, top: Tile floor, Spanish, about 1425–50. Tin-glazed earthenware, 48 x 72 in. JPGM 84.DE.747

p. 57, bottom: Blue and white dish with a merchant ship, Italian (Cafaggiolo), about 1510. Tin-glazed earthenware, 1⅞ x 9⁹⁄₁₆ in. JPGM 84.DE.109

p. 58: Jean-Étienne Liotard (Swiss, 1702–1789), *Dame pensive sur un sofa*, 1749. Pastel on parchment, 9⁵⁄₁₆ x 7½ in. Cabinet d'arts graphiques des Musées d'art et d'histoire, Genève, Dépôt de la Fondation Gottfried Kelle, 1930-0002. Musée d'Art et d'Histoire, Geneva, Switzerland/Giraudon/The Bridgeman Art Library

p. 59, left: Gerrit Dou (Dutch, 1613–1675), *Astronomer by Candlelight*, late 1650s. Oil on panel, 12⅝ x 8⅜ in. JPGM 86.PB.732

p. 59, right: Jacob van Hulsdonck (Flemish, 1582–1647), *Still Life with Lemons, Oranges, and a Pomegranate*, about 1620–40. Oil on panel, 16½ x 19½ in. JPGM 86.PB.538

p. 60, left: Frans van Mieris the Elder (Dutch, 1635–1681), *Pictura (An Allegory of Painting)*, 1661. Oil on copper, 5 x 3½ in. JPGM 82.PC.136

p. 60, right: After Ann-Louis Girodet de Roucy-Trioson (French, 1767–1824), *Burial of Atala*, after 1808. Oil on canvas, 19⅞ x 24⅜ in. JPGM 83.PA.335

p. 61: Georg Dionysius Ehret (German, 1708–1770), Johann Jakob Haid (German, 1704–1767), and Christoph Jacob Trew (German, 1695–1769), *Indigofera* from *Plantae Selectae Quarum Imagines ad Exemplaria Naturalia Londini, in Hortis Curiosorum Nutrit*, 1760. Image courtesy Missouri Botanical Garden, www.botanicus.org

p. 62: *Psyche at the Basketmakers*, French (Beauvais Manufactory), about 1750. Silk and wool, after design by François Boucher (French, 1703–1770), 136 x 99 in. JPGM 63.DD.4

p. 63, top: Oscar Mallitte (British, about 1829–1905, active Allahabad, India 1870s), *Beating a Vat by Hand*, 1877. Albumen silver print, 7³⁄₁₆ x 9⁵⁄₁₆ in. JPGM 84.XO.876.8.9

p. 63, bottom: Advertisement for Levi's, tradecard from about 1899. Courtesy Levi Strauss & Co. Archives

p. 64, left: Thomas Gainsborough (English, 1727–1788), *The Blue Boy*, about 1770. Oil on canvas, 70⅝ x 48¾ in. San Marino, California, The Huntington Library, Art Collections, and Botanical Gardens. © The Huntington Library, Art Collections & Botanical Gardens/The Bridgeman Art Library

p. 64, right: X-ray, *The Blue Boy*. © Courtesy the Huntington Art Collections, San Marino, California

p. 65: *Newton's Optics*, Science Photo Library H414/0126. Photo Researchers

p. 66: Cornelis Bega (Dutch, 1631/1632–1664), *The Alchemist*, 1663. Oil on panel, 14¼ x 12¹¹⁄₁₆ in. JPGM 84.PB.56

p. 67, left: *A Fox with a Chicken*, German (Meissen Porcelain Manufactory), 1732. Hard-paste porcelain with traces of oil paint, model by Johann Gottlieb Kirchner (German, born 1706), 18 x 12⅜ x 7⅞ in. JPGM 2002.47

p. 67, right: Ewer, French (Sèvres Manufactory), 1757. Soft-paste porcelain, pink ground color, polychrome enamel decoration, and gilding, 7⁹⁄₁₆ x 5⅝ x 3³⁄₁₆ in. JPGM 84.DE.88.1

p. 68: Jean-Étienne Liotard (Swiss, 1702–1789), *Still Life: Tea Set*, about 1781–83. Oil on canvas mounted on board, 14⅞ x 20⁵⁄₁₆ in. JPGM 84.PA.57

p. 69: Lidded potpourri vase, French (Sèvres Manufactory), about 1760. Soft-paste porcelain, pink and green ground colors, polychrome enamel decoration and gilding, 14¾ x 13¹¹⁄₁₆ x 6¹³⁄₁₆ in. JPGM 75.DE.11

p. 70, top: Johannes Vermeer (Dutch, 1632–1675), *Girl Reading a Letter at an Open Window*, about 1659. Gemäldegalerie Alte Meister, Staatliche Kunstsammlungen Dresden. bpk, Berlin/Gemaeldegalerie Alte Meister, Staatliche Kunstsammlungen, Dresden, Germany/photo: Elke Estel/Hans-Peter Klut/Art Resource, NY

p. 70, bottom: Jean-François Millet (French, 1814–1875), *The Cat at the Window*, about 1857–58. Charcoal, black and white chalk with touches of pastel, 19⅝ x 15½ in. JPGM 96.GF.12

p. 71: Pigment scoops from Winsor and Newton Image by kind permission of Winsor and Newton

p. 72: Watercolor paint box, English, about 1780–1800. Wood, watercolor cakes, and artists' tools, 7³⁄₁₆ x 12¼ x 3¼ in. GRI 1365-985 910133*

p. 73, top left: Joseph Mallord William Turner (British, 1775–1851), *Long Ship's Lighthouse, Land's End*, about 1834–35. Watercolor and gouache, scraped by the artist, 11¼ x 17⁵⁄₁₆ in. JPGM 88.GC.55

p. 73, top right: Indian yellow pigment balls from Winsor and Newton. Image by kind permission of Winsor and Newton

p. 73, bottom: Joseph Mallord William Turner (British, 1775–1851), *Modern Rome—Campo Vaccino*, 1839. Oil on canvas, 36⅛ x 48¼ in. JPGM 2011.6

p. 74: Color wheel, plate 3 from *Des couleurs et de leurs applications aux arts industriels à l'aide des cercles chromatiques*, by Michel Eugène Chevreul (French, 1786–1889) and René Digeon, 1864. GRI 90-B8575

p. 75, top: *Sancho's Entry on the Isle of Barataria*, from The Story of Don Quixote series, French (Gobelins Manufactory), 1772. Silk and wool, 145 x 163 in. JPGM 82.DD.68

p. 75, bottom: *Gobelin Low Warp Tapestry* (*Tapisserie de basse-lisse des Gobelins*) from *Encyclopédie ou Dictionnaire raisonné des sciences, des arts et des métiers*, vol. 9, by Denis Diderot and Jean le Rond d'Alembert, 1771

p. 76, top: *Le jaune orange a pour complémentaire le bleu* from *L'harmonie des couleurs* by Édouard Guichard (French, born 1815), 1880. GRI 94-B21035

pp. 76–77, bottom: Bridget Riley (British, born 1931), *To a Summer's Day*, 1980. Acrylic paint on canvas, 45½ x 110¾ in. Private collection. © Bridget Riley 2014. All rights reserved, courtesy Karsten Schubert, London. Photo © Christie's Images/The Bridgeman Art Library

p. 77, top: Albert Dubois-Pillet (French, 1846–1890), *The Banks of the Marne at Dawn*, about 1888. Watercolor over traces of black chalk, 6¼ x 8¾ in. JPGM 2008.25

p. 78: Hendrick Avercamp (Dutch, 1585–1634), *A Winter Scene with Two Gentlemen Playing Colf*, about 1615–20. Pencil, pen and ink, and gouache, 3¹¹⁄₁₆ x 6⅛ in. JPGM 2008.13

p. 79: Théodore Géricault (French, 1791–1824), *Horses and Riders*, 1813–14. Graphite, 8¼ x 11 in. JPGM 88.GD.46

p. 80: Jean-Auguste-Dominique Ingres (French, 1780–1867), *Portrait of Lord Grantham*, 1816. Graphite, 15¹⁵⁄₁₆ x 11⅛ in. JPGM 82.GD.106

p. 81, top: Mummified heads from Thebes from *Description de l'Égypte, ou, Recueil des observations et des recherches qui ont été faites en Égypte pendant l'expédition de l'armée française: Antiquités, planches, tome deuxième*, 1812; Antoine Maxime Monsaldy (French, 1768–1816), after André Duterte (French, 1753–1842), after Henri-Joseph Redouté (French, 1766–1852). 16¼ x 43¾ in. GRI 83-B7948.c1.antiqpl.v2

p. 81, bottom: Underwood & Underwood, *Buried for Ages, Colonnaded Terraces of Queen Makere's Temple, Der-el-Bahri, Thebes, Egypt*, 1904. Stereograph. GRI 2008.R.3

p. 83: People throwing colored water and colored powder on each other while celebrating the festival of Holi in Barsana and Nandgaon. © Himanshu Khagta/Alamy

p. 84, left: William Henry Perkin (British, 1838–1907), *Portrait of English Chemist, Sir William H. Perkin*, 1852; Science Photo Library, H416/0154. Photo Researchers

p. 84, right: Day dress, British or French, 1873. Silk and ruching. Given by the Marchioness of Bristol, London, Victoria and Albert Museum, T.51&A-1922 . V&A Images, London/Art Resource, NY

p. 85, left: Mauve sample from *The American Practical Dyer's Companion* by F. J. Bird, 1882. GRI 84-B25071

p. 85, right: Jacques Joseph Tissot (French, 1836–1902), *Portrait of the Marquise de Miramon, née Thérèse Feuillant*, 1866. Oil on canvas, 50½ x 30⅜ in. JPGM 2007.7

p. 86: Jean-Antoine Watteau (French, 1684–1721), *The Italian Comedians*, about 1720. Oil on canvas, 50¾ x 36¾ in. JPGM 2012.5

p. 87: Canaletto (Giovanni Antonio Canal) (Italian, 1697–1768), *The Grand Canal in Venice from Palazzo Flangini to Campo San Marcuola*, about 1738. Oil on canvas, 18½ x 30⅜ in. JPGM 2013.22

p. 88, left: Blueprint, New building for Duveen brothers, New York City. Elevation by René Sergent, 1910. GRI 930092

p. 88, right: Anna Atkins (British, 1799–1871) and Anne Dixon (British, 1799–1877), *Equisetum sylvaticum*, 1853. Cyanotype, 10 x 7⅞ in. JPGM 84.XO.227.45

p. 89: Utagawa Hiroshige (Japanese, 1797–1858), *Suruga-chō*, from *One Hundred Famous Views of Edo* series, about 1856–59. Color woodblock print, 14¼ x 9³⁄₁₆ in. Los Angeles County Museum of Art, M.73.75.26. www.lacma.org

p. 90: John Everett Millais (English, 1829–96), *The Ransom*, 1860–62. Oil on canvas, 51 x 45 in. JPGM 72.PA.13

p. 91, left: Jacques-Louis David (French, 1748–1825), *The Emperor Napoleon in His Study at the Tuileries*, 1812. Oil on canvas, 80¼ x 49¼ in. Samuel H. Kress Collection. Washington, DC, National Gallery of Art, 1961.9.15. Courtesy National Gallery of Art, Washington

p. 91, right: Bowl, Late Hellenistic or Roman, end of 1st century BC–beginning of 1st century AD. Glass, 1⁵⁄₁₆ x 2⅞ in. JPGM 2003.232

p. 92: William Henry Fox Talbot (English, 1800–1877), *The Ladder*, 1844. Salted paper print, 6¹¹⁄₁₆ x 7⅛ in. JPGM 84.XZ.571.14

p. 93, left: Alphonse Maria Mucha (Czech, 1860–1939), *Female Model Wearing a Tiara*, Paris, negative 1899, print about 1980. Sepia-toned gelatin silver print, 11⁹⁄₁₆ x 8¼ in. JPGM 2009.113.9

p. 93, top right: *Portrait of Edgar Allan Poe*, American, 1849. Daguerreotype, 4¹³⁄₁₆ x 3½ in. JPGM 84.XT.957

p. 93, bottom right: Antoine Claudet (French, 1797–1867), *Portrait of a Girl in Blue Dress*, about 1854. Daguerreotype, hand colored, 2½ x 2¹⁄₁₆ in. JPGM 84.XT.833.17

p. 94: Claude Monet (French, 1840–1926), *Wheatstacks, Snow Effect, Morning*, 1891. Oil on canvas, 25½ x 39¾ in. JPGM 95.PA.63

p. 95, left: Claude Monet (French, 1840–1926), *The Portal of Rouen Cathedral in Morning Light*, 1894. Oil on canvas, 39½ x 25⅝ in. JPGM 2001.33

p. 95, right: Claude Monet (French, 1840–1926), *Rouen Cathedral, West Facade, Sunlight*, 1894. Oil on canvas, 39⅜ x 25⅞ in. Chester Dale Collection. Washington, DC, National Gallery of Art, 1963.10.179. Courtesy National Gallery of Art, Washington

p. 96: Édouard Manet (French, 1832–1883), *Portrait of Madame Brunet*, about 1860–63, reworked by 1867. Oil on canvas, 52⅛ x 39⅜ in. JPGM 2011.53

p. 97, left: MarsDial. NASA/JPL/Cornell University/ Arizona State University/Courtesy Jim Bell

p. 97, right: A view of Mars taken by the *Opportunity* rover, 2012. NASA/JPL/Cornell University/Arizona State University/Don Davis/Courtesy of The Planetary Society. © Don Davis

p. 98: Vincent van Gogh (Dutch, 1853–1890), *Irises*, 1889. Oil on canvas, 29¼ x 37⅛ in. JPGM 90.PA.20

p. 99: Vincent van Gogh (Dutch, 1853–1890), *The Night Cafe*, 1888. Oil on canvas, 28½ x 36¼ in. New Haven, Yale University Art Gallery, 1961.18.34

p. 100: Sergey Prokudin-Gorsky (Russian, 1863–1944), *Emir of Bukhara*, 1911. Library of Congress LC-DIG-prokc-21886

p. 101, top: Auguste Marie Louis Nicolas Lumière (French, 1862–1954) and Louis Jean Lumière (French, 1864–1948), *Gold Lyre Table Clock*, about 1898. All-Chroma autochrome, each image: 2⅞ x 2⅝ in. JPGM 84.XT.838.13

p. 101, bottom: Frederick S. Dellenbaugh (American, 1853–1935), *Still Life with Ornate Chinese Vase*, about 1910. Autochrome, 6⁹⁄₁₆ x 4⁹⁄₁₆ in. JPGM 84.XH.710.10

p. 102: Alfred Stieglitz (American, 1864–1946), *Kitty Stieglitz*, 1907. Autochrome, 5⅝ x 3⅞ in. JPGM 85.XH.151.5

p. 103: Wassily Kandinsky (Russian, 1866–1944), *Impression III (Concert)*, 1911. Oil on canvas. Munich, Städtische Galerie im Lenbachhaus. Peter Willi/The Bridgeman Art Library

p. 104: Edvard Munch (Norwegian, 1863–1944), *Starry Night*, 1893. Oil on canvas, 53⅜ x 55⅛ in. JPGM 84.PA.681

p. 105: Hans Namuth (German, 1915–1990), *Mark Rothko*, 1964. Cibachrome print, 13⅝ x 19⅝ in. © 1991 Hans Namuth Estate. Courtesy Center for Creative Photography, University of Arizona. © 1998 Kate Rothko Prizel and Christopher Rothko/Artists Rights Society (ARS), New York

p. 106: Yves Klein (French, 1928–1962), *Blue World Globe*, 1962. Pure pigment and synthetic resin on plaster, 14³⁄₁₆ x 8½ x 7¾ in. Private collection. Banque d'Images, ADAGP/Art Resource, NY. © 2014 Artists Rights Society (ARS), New York/ADAGP, Paris

p. 107: Jean Bourdichon (French, 1457–1521), *Louis XII of France Kneeling in Prayer, Accompanied by Saints Michael, Charlemagne, Louis, and Denis*, from the Hours of Louis XII, Tours, 1498–99. Tempera and gold on parchment, 9⁹⁄₁₆ x 6³⁄₁₆ in. JPGM 2004.1.recto

pp. 108–9: Roy Lichtenstein (American, 1923–1997), *Whaam!*, 1963. Acrylic and oil on canvas, 68 x 160 in. London, Tate, T00897. Tate, London/Art Resource, NY/© Estate of Roy Lichtenstein.

p. 109, center: Cover of the April 1938 issue of *Action Comics*, featuring the first appearance of the character Superman, created by Jerry Siegel and Joe Shuster. The Granger Collection, NYC Image No. 0115423

p. 109, right: Close-up of Benday dots

p. 111, left: Roy Lichtenstein (American, 1923–1997), *Three Brushstrokes*, 1984. Painted aluminum, 121½ x 28½ x 39½ in. Gift of Fran and Ray Stark, JPGM 2005.111. © Estate of Roy Lichtenstein

p. 111, right: Postbox. Photograph courtesy the author

p. 112: Visitors study untitled works by artist Dan Flavin at his retrospective exhibition in the Hayward Gallery on London's South Bank, Wednesday, January 18, 2006. Photo: Graham Barclay/Bloomberg via Getty Images © 2014 Stephen Flavin/Artists Rights Society (ARS), New York

p. 113: David Hockney (British, born 1937), *Yosemite I, October 16ᵗʰ 2011*, 2011. iPad drawing printed on paper (6 sheets), mounted on Dibond (6 sheets), 143½ x 128¼ in. © David Hockney

Index

Acknowledgments

So many wonderful people have helped with this book. They include most of the Getty's art experts in California; gallery curators around the world who gamely answered obscure questions about what pigments were (or might have been) used in their paintings; photographers (in one case of the planet Mars); scientists; educators; administrators; artists; and kind people who, even on busy days, were willing to sit down over a cup of coffee and give their time and expertise to someone they didn't know. When I look at the names that follow I also think of expeditions underground to locked basement rooms where bright treasures are held, of rare library manuscripts, and of dinners and hospitality and generosity (and a late-night dash around the hills of Los Angeles to pick up a cactus with real cochineal on it).

Thank you then to Maite Alvarez, Kirsten Andrews, Sylvana Barrett, John Beer, Jim Bell, Antonia Boström, David Brafman, Charissa Bremer-David, Madeline Bryant, Giacomo Chiari, Don Davis, Jim Druzik, Elizabeth Escamilla, Rob Flynn, Andrew Goodhouse, Mark Heineke, Catherine Hess, Bryan Keene, Martin Kemp, Peter Kerber, Kara Kirk, Edouard Kopp, Ruth Lane, Kenneth Lapatin, Paul Martineau, Melinda McCurdy, Pam Moffat, Elizabeth Morrison, Bill Nye, Alan Phenix, Jerry Podany, Marcia Reed, Caroline Roberts, Paul Robinson, Sandy Rodriguez, Scott Schaefer, Karen Schmidt, Natasha Seery, Miranda Sklaroff, Margaret Walton Smith, Theresa Sotto, Dusan Stulik, Marie Svoboda, Yvonne Szafran, Frances Terpak, Karen Trentelman, Nancy Turner, Giovanni Verri, Suzanne Watson, Kimberly Wilkinson, Iris Winkelmeyer, Julie Wolfe, Anne Woollett, William Zaluski, and many others. You all helped me hugely: any mistakes that remain are my own responsibility.

I'd also like to mention Phil Shepherd and the kids of Class 7 at Hexthorpe Primary School in Doncaster, UK, whose questions out of the blue about "the wee of cows in India" and other enticing stories from the history of colors helped inspire me to change the structure of this book so it became all about the paints. And of course my husband, Martin Palmer, who's always been so supportive, and who promises he's forgiven me for once making him spend more than four hours looking around the Pencil Museum in Keswick.

But *Brilliant History* would not have existed at all without Getty designer Kurt Hauser, who created amazing pages out of all sorts of random boxes and pictures and different sizes of text, and my wonderful (and astonishingly patient) editor Elizabeth Nicholson. They both invented the idea of this book, and believed it into being, and I'm so grateful they brought me in to help it happen. Thank you.

Victoria Finlay

© 2014 J. Paul Getty Trust
Third printing

Published by the J. Paul Getty Museum, Los Angeles
Getty Publications
1200 Getty Center Drive, Suite 500
Los Angeles, California 90049-1682
www.getty.edu/publications

Elizabeth S. G. Nicholson, *Project Editor*
Ann Grogg, *Manuscript Editor*
Kurt Hauser, *Designer*
Suzanne Watson, *Production Coordinator*
Pam Moffat and Andrew Goodhouse, *Photo Research*
Rebecca Vera-Martinez, *Imaging*

Printed in China